Beginning
OIL

Tips and techniques for learning to paint in oil

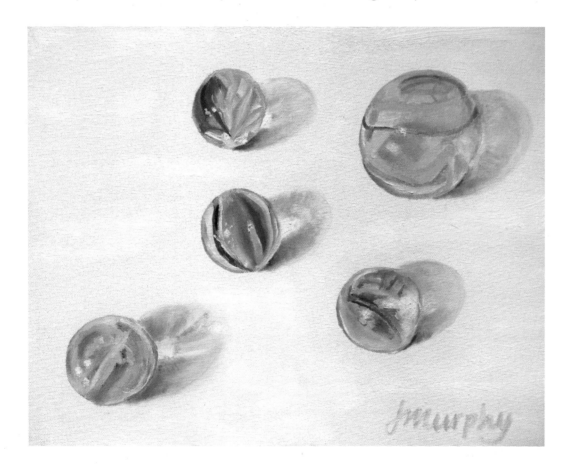

Quarto is the authority on a wide range of topics.
Quarto educates, entertains, and enriches the lives of our readers—
enthusiasts and lovers of hands-on living.
www.quartoknows.com

© 2017 Quarto Publishing Group USA Inc.
Published by Walter Foster Publishing,
a division of Quarto Publishing Group USA Inc.
All rights reserved. Walter Foster is a registered trademark.

Artwork © Jan Murphy
Design: Melissa Gerber

6 Orchard Road, Suite 100
Lake Forest, CA 92630
quartoknows.com

Visit our blogs at quartoknows.com

This book has been produced to aid the aspiring artist. Reproduction of work for study
or finished art is permissible. Any art produced or photomechanically reproduced from this
publication for commercial purposes is forbidden without written consent from the publisher,
Walter Foster Publishing.

Printed in China
1 3 5 7 9 10 8 6 4 2

FSC
www.fsc.org
MIX
Paper from
responsible sources
FSC® C016973

Table of Contents

Introduction

"IF YOU HEAR A VOICE WITHIN YOU SAY, 'YOU CANNOT PAINT,' THEN BY ALL MEANS PAINT, AND THAT VOICE WILL BE SILENCED."
—Vincent van Gogh, Dutch painter

Oil paint is a forgiving and versatile medium. Its slow drying time and vibrant colors make it ideal for beginning artists. This book will teach you myriad oil-painting concepts and techniques, including brushstrokes, understanding form, painting various subjects, and more. There are many styles of painting, from abstract to hyperrealism. The lessons demonstrated in this book are primarily landscapes and objects.

Just as athletes must practice at their chosen sport to improve their skills and strength, artists of all levels must practice, practice, practice. The exercises in this book will help you improve as an artist as you practice them multiple times and on different surfaces.

Set target dates for completing the lessons. Choose times to practice painting when you won't be disturbed. Select music that inspires you.

A blank canvas on an easel can be a challenging sight for an artist of any skill level. Placing a three-dimensional world into a two-dimensional one requires knowledge. Learning to paint is essentially knowing how to observe and see relationships between objects.

Artists of all levels become frustrated at times. Realize that this can happen, but that you have the ability to work through that frustration. Always have at least three canvases on hand, and work on several pieces at a time. Then, if you get stuck on one painting, you can take a break and move to another.

No two painters are alike. Some work in detail, such as John James Audubon in his book *The Birds of America*. Some painters paint quickly without much detail. Most are somewhere in between. You will find your style. Begin by studying technique, composition, color, and value. You have an unlimited number of subjects to observe and from which to create unique impressions. Your paintings will be unlike anyone else's work.

Congratulations on your new exploration into oil painting. The world needs more artists ... like you.

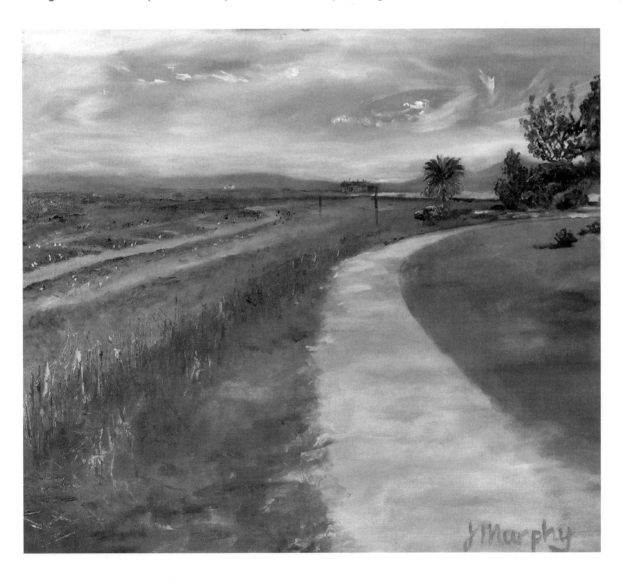

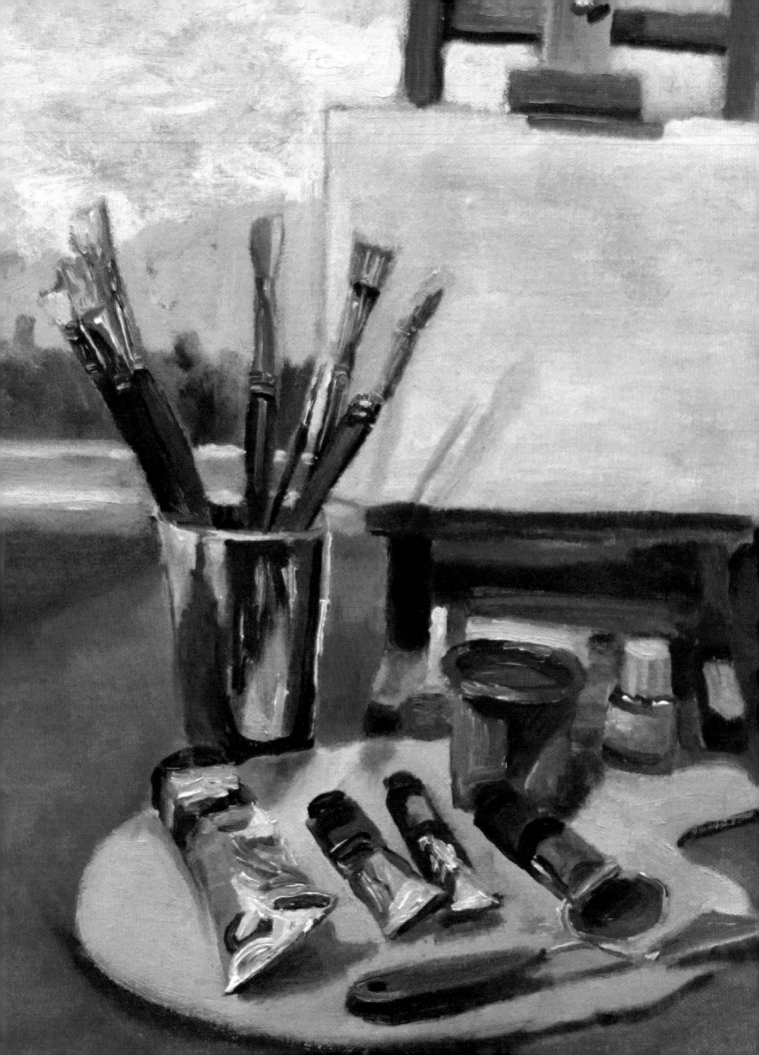

GETTING
Started

Tools & Materials

If you're happy with the quality of your materials, you're more likely to get out there and paint. If you simply walk into your local art-supply store, you might become overwhelmed with the amount of equipment available for oil painters. It's not important to get every possible piece of equipment when you're just starting out. It's more important and economical over time to get the essential items. When purchasing supplies, choose the best possible quality for your budget. Poor-quality materials can cause you unnecessary frustration. Good tools, however, will make your work easier and more fun.

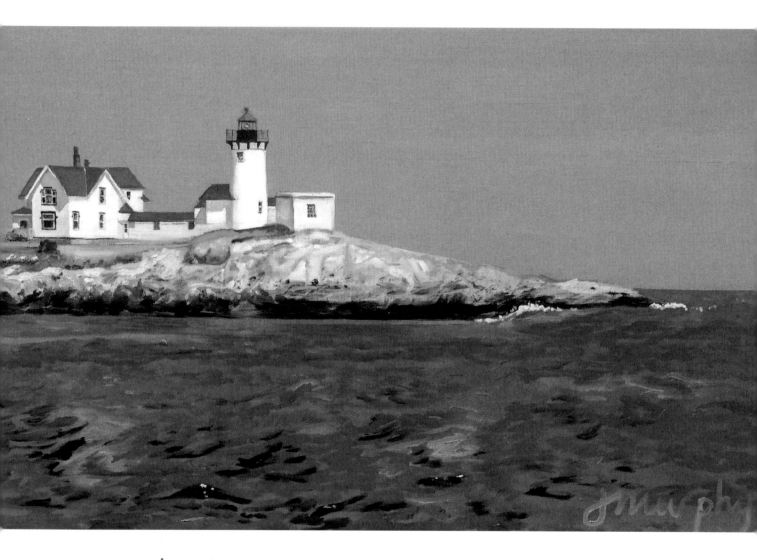

tips

FOCUS ON THESE ITEMS FIRST: PAINTS, BRUSHES, SURFACES, AN EASEL, AND A PALETTE.

PAINTS

Oil paint is made by grinding pigment (color) with natural oil. The final color can be transparent, translucent, or opaque. The benefit of painting with oil is that it dries slower than acrylics and watercolor. This allows you to work on your painting for a longer period of time and to rework areas if necessary. One of the drawbacks, however, is that cleanup can be messier and may involve the use of solvents, such as turpentine.

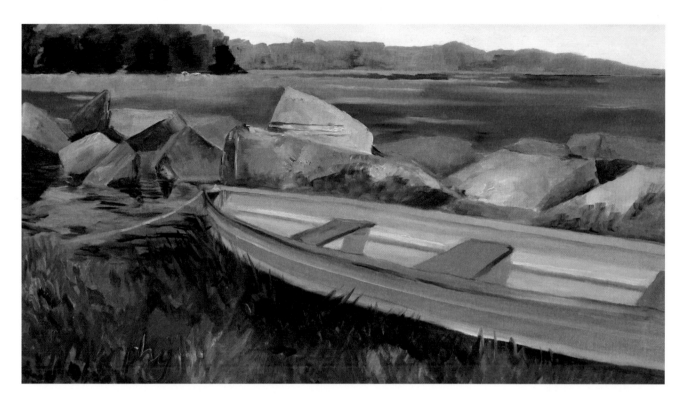

SOLVING SOLVENTS

Turpentine fumes can be harmful, so always use it in a well-ventilated area. There are low-odor products available, but their fumes can still be harmful to your health. Consider using a protective face mask when working with turpentine. Linseed oil and oil of spike lavender are less-toxic options for thinning your paint.

Another option is to paint with water-soluble oils. These paints are thinned with water instead of solvents and are cleaned using mild soap and water. Water-soluble paints are an excellent choice for beginners.

TIPS FOR BUYING PAINTS

Prices can vary between brands and colors. The quality can also be quite different between brands. Watch for sales at art-supply stores and online. When starting out, buy paint that fits in your budget. As you experiment, you will find brands and colors that you prefer.

There are differences between professional- and student-grade paints. Student-grade paints contain less pigment and are less expensive, while the pigment in professional-grade paint gives it a more intense color. You might consider selecting professional grade for brighter colors and student grade for neutral colors.

tip

TO CONSERVE PAINT, MIX A SMALL AMOUNT OF DARK PIGMENT INTO A LARGER AMOUNT OF WHITE, OR YOU'LL END UP MIXING TOO MUCH PAINT.

You will find that you use more of the lighter paint colors. Consider buying a larger tube of white paint, because you will use more white than any other color. You will need a smaller tube of darker paints, such as phthalo blue. When mixing your tints, you'll use a larger amount of white than blue.

DRYING TIMES

One beauty of painting in oil is that it takes longer to dry. This gives you the opportunity to go back to blend and rework areas. An oil painting can feel dry to the touch in anywhere from two to ten days, depending upon how much paint is used. If the top layer dries before the bottom layer, it can shrink and cause cracking. Multiple factors affect drying time, including:

- The type of oil used in the paint. Linseed oil is used most often.
- The type of oil that you might mix into the paint
- The paint manufacturer
- The color itself. For example, titanium white is a slower-drying paint. Naples yellow dries faster.
- The thickness of your application
- Environmental factors

tip

OIL PAINTS ARE A SLOWER MEDIUM. ENJOY THE PROCESS.

CHOOSING YOUR COLOR PALETTE

A quick search online for oil paint will reveal hundreds of different colors from which to choose. You'll never need them all. You will only need six to fifteen different colors. Over time, you will find that your palette might lean toward brighter or duller colors, depending on your preference. You won't need all of the colors on the palette for all lessons, and that will conserve your paints. Notice that there is no black on the list below. You will learn how to mix warm or cool blacks and grays on page 44.

FOR THE LESSONS IN THIS BOOK, YOU WILL WORK WITH THIRTEEN COLORS:

- titanium white
- cadmium yellow light
- cadmium yellow dark
- yellow ochre
- cadmium orange
- cadmium red light
- alizarin crimson
- quinacridone magenta
- dioxazine purple
- ultramarine blue
- phthalo blue
- phthalo green
- chrome oxide green

TAKING CARE OF YOUR OIL PAINTS

1. Use a rag or paper towel to clean the threads of your oil paint tubes after putting paint on your palette to avoid buildup.

2. Always squeeze the paint tube from the bottom. Buy an inexpensive tube roller to help get all of the paint out of the tube.

BRUSHES

"REAL PAINTERS UNDERSTAND WITH A BRUSH IN THEIR HAND."

—Berthe Morisot, French painter

There are three types of brushes for oil painting: bristle, sable, and synthetic. Bristle brushes are made from hog hair, very durable, and they last a long time. Sable brushes are made from weasel hair and are very soft. They are typically more expensive, but they are also strong and will stand up to your paints and give you a smooth stroke. Synthetic brushes are cheaper. Make sure that the brushes you use are designed for oil paints. Oil paints require a brush that will stand up to the thickness of the paint.

Your brush is an extension of your hand and eyes and makes a big difference in technique. Choose a sable brush when you want flatness or smoothness. Bristle brushes are best for creating texture. When covering large areas, use a wide bristle brush, as it will take less time to apply the paint.

Once you are ready to buy brushes, look out for a few things. In an art-supply store, touch the brushes to see how they respond. Bad brushes don't return to their shape or bend properly. Purchase the best brush that you can afford at the time. You don't want to be fighting with your brush while you paint.

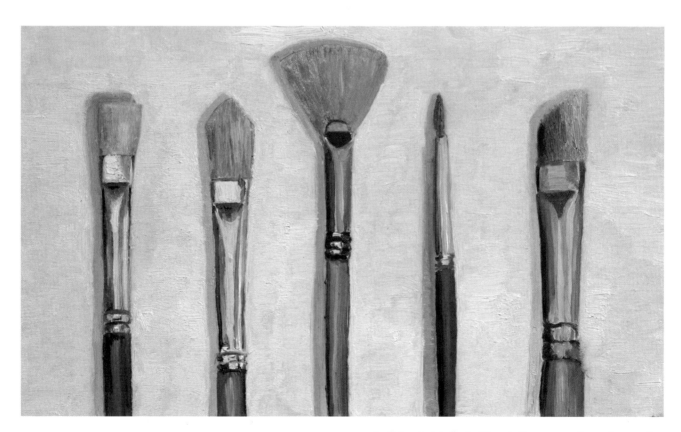

Left to right: flat, filbert, fan, round, and angular

Brushes come in many shapes and sizes. To start, you'll only need a few different shapes. See what works for you by trying them out. Let's take a look at some brush shapes to consider.

FLAT

You will use these brushes for applying large areas of paint. They come in two hair lengths: short and long. Short-hair flat brushes are called "brights."

FILBERT

Filberts are a hybrid of rounds and flats. They start off wide at the bottom and taper to a rounded head. This brush will leave a smooth finish.

FAN

You won't need this type of brush immediately to begin your work. They are great to use when softly blending areas.

ROUND

The hair on these brushes is typically long and comes to a point at the end. Extra-long round brushes are called "riggers". They are particularly good for details, such as tree branches and signatures.

ANGULAR

Angular brushes are short on one end and longer on the other. They are used for lines and curves.

BRUSH HANDLE SIZES

You will notice that there are two different lengths of brush handles: long and short. Use a longer handle when you stand at arm's length from your canvas and use looser strokes. A shorter brush handle is great for detail work when you stand or sit closer to the canvas.

BRUSH SIZES

Brush sizes can be baffling at first. If you are working on a small canvas, you will want to use smaller brushes, which are ideal for detail work.

TAKING CARE OF YOUR BRUSHES

Taking good care of your brushes is an economical move in the long run, because they will last longer. You can use certain products for brush cleaning and conditioning, but some are quite expensive. If you use water-soluble oil paints, you can use mild soap and water for cleanup as a low-cost option.

Detergents can be too harsh and will strip the oils from natural-hair brushes, and turpentine will make your brushes brittle over time. Here is a natural method for cleaning your brushes:

1. Remove the excess paint by wiping the brush with a rag or paper towel.

2. Dip your brush into a container of inexpensive vegetable oil. Wipe the brush on a rag several times to remove excess paint until the paint is gone.

3. Dip your brush into a container of mild liquid soap, and scrub the bristles onto another clean surface.

4. Rinse with water until the water runs clear.

Store your brushes flat or standing in a container with the handle side down. If you find that your brush bristles become dry, you can occasionally use a natural hair conditioner to bring them back to life.

You will develop favorites among your brushes. Once you've completed several projects, add new brushes to build up your collection. Don't throw out brushes that have lost their shape. You won't use them often, but they can sometimes make good texture brushes.

tip

ARTISTS OFTEN WASH THEIR BRUSHES BY SCRUBBING THEM AGAINST THE PALMS OF THEIR HANDS. AS A PAINTER WHO HAPPENS TO ALSO BE A TENNIS PLAYER, LET ME OFFER THIS SUGGESTION:

1. CUT A TENNIS BALL IN HALF.

2. HOLD THE TENNIS BALL HALF IN THE PALM OF YOUR NON-DOMINANT HAND.

3. SCRUB THE BRUSH AGAINST THE INSIDE OF THE TENNIS BALL.

PAINTING SURFACES

"LIFE IS A GREAT BIG CANVAS; THROW ALL THE PAINT YOU CAN AT IT."
—Danny Kaye, American actor and comedian

CANVAS

Canvas is the most commonly used surface for oil painting. Other surfaces include paper, wood, and metal. Some artists stretch and prime their own canvases. Beginning artists are better off learning to paint than preparing canvases, however.

Be sure to choose a canvas that has been primed with acrylic or oil paint. Experiment with different surfaces to determine which you prefer for painting.

If you want to paint an image in fine detail, choose a smooth surface. Hardboard panels are excellent for attaining a smooth look. If you are going to paint with heavily or loosely applied paint, look for a coarser grain, which will hold the paint better.

STRETCHED COTTON & LINEN CANVAS

Canvas is available in cotton and linen. Linen is more expensive than cotton, but it is also more durable and resists decay. The best canvas surface for a beginning artist to start with is cotton. Get comfortable with painting before going to the expense of painting on linen. When you decide to try linen, you will notice some differences from cotton. The paint doesn't soak into linen canvas as much, but it offers the smoothest surface and doesn't expand or contract as much as cotton. Both cotton and linen canvases are available in different textures, from smooth to rough.

Stretched canvas is cotton or linen canvas that has been stretched over a wooden frame. Framing can be expensive. Purchasing a stretched canvas that has been stapled in the back will save you money on framing. Paint the side edges, and they're ready to hang!

CANVAS ON PANEL

You'll also find canvases that are glued to a wooden or cardboard panel. They are lightweight, easy to transport, and less expensive than stretched canvas. Canvas panels are ideal for beginning painters.

CANVAS PAPER

Canvas paper is sold in pads of tear-off sheets. It is already primed and ready to use. This paper works well for painting exercises.

WOOD PANELS

Hardboard panels are more durable than canvases. They are stiff, so they're less likely to crack, easy to transport, and less vulnerable to tears than stretched canvases. The sun won't shine through the back, making it easier to paint outdoors. You will notice that hardboard panels are less expensive than canvas. Some manufacturers prime them with a neutral color.

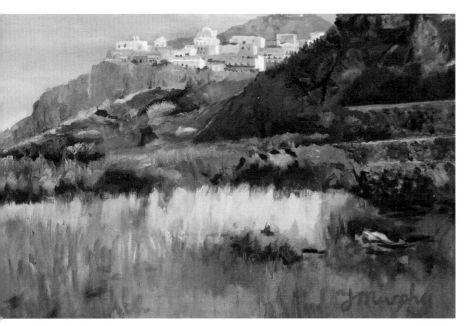

PAPER

Any type of paper or card can be painted on as long as it's primed. Since oil will sink into unprimed paper, a coating first needs to be applied. Try several types of surfaces. You will find that you gravitate toward certain painting surfaces.

LEONARDO DA VINCI PAINTED THE MONA LISA ON A POPLAR WOOD PANEL.

WHAT DO PAINTING MARKS LOOK LIKE ON DIFFERENT SURFACES?

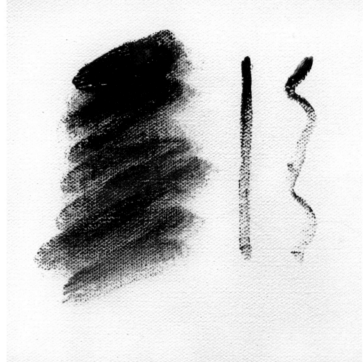

Heavy-textured cotton canvas

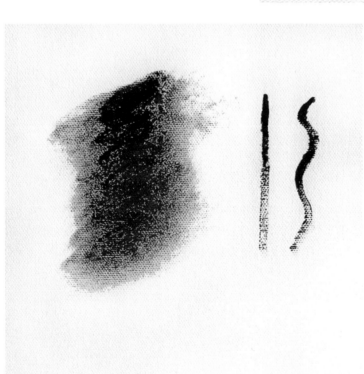

Medium-textured cotton canvas

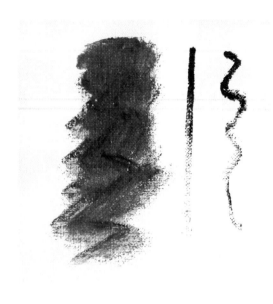

Smooth linen canvas

Hardboard primed with white gesso

Hardboard primed with neutral gesso

Paper primed for oil. Notice that the color absorbs into the paper more than with the other surfaces.

FIXING A TORN CANVAS

Canvases can accidentally tear. It's good to repair a tear early before it gets any larger. If a small tear happens, the most important advice is to repair it from the back. Here's how to do it.

1. Cut a piece of canvas or other strong fabric into a square larger than the tear.

2. Apply a thin layer of acid-free glue, such as white craft glue, to the back of your painting where the canvas tore.

3. Hold it in place with masking tape until it dries.

4. Turn your painting to the front, and make sure that the tear is aligned well.

5. Touch up the painting if necessary.

GETTING TO KNOW EASELS

It's important to have a quality easel. It doesn't have to be large, but it should be sturdy, so that you won't become frustrated. Look for an easel that moves up and down so you can paint on different canvas sizes. A table easel is a great starting option.

Some easels have dual purposes. They can be used on a table and are also easily portable for painting outdoors. Some have legs for painting while standing up. Others, like the one on the left, use tripods that attach to a paint box, which can be removed for painting on a table. If you're painting outdoors, the terrain can often be uneven, so look for portable easels with adjustable legs. There are lots of styles and brands of these types of easels. Choose one that fits into your budget.

STUDIO EASELS

Studio easels are full-sized and designed to hold large canvases. They tend to be the most sturdy and are easily adjustable to different heights. You won't need a large easel to start out, but think about buying one someday.

PALETTES

"IN OUR LIFE THERE IS A SINGLE COLOR, AS ON AN ARTIST'S PALETTE, WHICH PROVIDES THE MEANING OF LIFE AND ART. IT IS THE COLOR OF LOVE."
—Marc Chagall, Russian/French artist

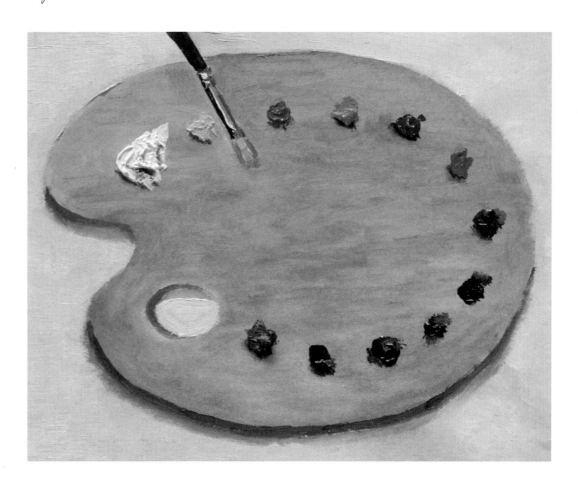

There are a variety of palette shapes and sizes out there. Choosing a palette is a personal choice. You can make one yourself from any flat, non-porous surface. The shape doesn't matter as much as the size. It's best to get a larger size than you think you might need so that you have enough room for mixing colors. Lightweight, lighter-colored wood helps when mixing colors. If you have a dark palette, the paint color will look lighter than it actually is. White palettes reflect light and can alter the appearance of the color. Neutral palettes work best for mixing colors.

WOODEN PALETTES are the most traditional. They are lightweight and inexpensive. You can generally buy one wooden palette for less than you would spend for one pad of paper palettes. A wooden palette will last a lifetime, whereas you will need to keep buying paper palettes. Before using your wooden palette, rub some linseed oil on it to prepare it. Wipe off any excess oil before applying paint.

To use an oval palette, place your thumb through the hole, and wrap your fingers around the palette. Hold it along your forearm between your elbow and wrist. Place the paint around the palette, keeping the middle available for mixing. Replenish the paint when you need it. You should be able to handle your palette without getting yourself dirty.

GLASS PALETTES have a smooth surface and are easy to clean. The drawbacks to glass palettes is that they are heavier and breakable. Make sure that you buy a safety-glass version with rounded edges. Tape a gray backing to the bottom to create a neutral background. If your paint dries on the glass palette, you can clean it off with a razor blade.

PAPER PALETTES are easy to use: Simply throw away the paper from the pad when you are finished for the day. Pads of paper palettes are produced with either white or neutral gray paper. One drawback to paper palettes is that they are more expensive. The advantage is that they make cleanup much easier.

CLEANUP

If you plan to paint days in succession, you don't need to clean your palette every day, because oil paint doesn't dry as quickly as acrylic paint. After a day, you will notice that a "skin" has developed on top of your blob of paint. You can pierce it to reveal the wet paint below. You will also notice that some paints dry faster than others. Use your palette knife to scrape off areas where the paint is almost used up. Then just wipe that area with a wipe or paper towel. You can also use a plastic container with a lid to keep your paints wet longer.

tip

WHEN PLACING YOUR PIGMENTS ON A PALETTE, MAKE SURE THERE IS ENOUGH ROOM TO ALLOW YOU TO PAINT FREELY. YOU WILL LIKELY USE MORE WHITE AND LIGHT COLORS THAN DARK PAINT.

THE VALUE OF PLACING PAINT ON YOUR PALETTE IN A CERTAIN ORDER

Set up the colors on your palette in the same order each time you paint. Make it a habit, and eventually you'll know exactly where to find your paints without having to look for them, which will free your mind to concentrate on your painting.

OTHER MATERIALS

PALETTE KNIVES

Palette knives can be used for mixing colors and laying color on a canvas. They can also be used to scrape paint off of your palette. Palette knives come in various shapes and sizes. You'll need one knife to begin.

COMFORTABLE, MESSY CLOTHES

Choose clothes that you don't mind getting paint on, such as old T-shirts. An apron is another good option. Watercolor and acrylic paints will wash out, whereas oil paints won't. If you do get some oil paint on your clothes, rub it with disinfecting wipes while the paint is still wet.

RAGS, PAPER TOWELS & DISINFECTING WIPES

You'll need plenty of rags and/or paper towels to wipe your brushes. Disinfecting wipes are also good for cleaning your brush between paint colors. If you make a mistake while painting, use a disinfecting wipe to clean your canvas.

PAINT THINNERS & SOLVENTS

Turpentine is a common type of thinner that's used to clean brushes and make paints more fluid. But in addition to health concerns regarding the odor of turpentine, its abrasiveness breaks the bond between pigment and oil, giving your painting a streaky look. It will also affect adhesion when creating multiple layers of paint. White spirit (or mineral spirit) is an alternative thinner. Like turpentine, it is streaky and not good for adhesion. Luckily, there are natural alternatives.

Painters since the Renaissance have used oil of spike lavender to thin their colors. The oil is distilled from a variety of lavender plant. A huge benefit of using this oil is that it's nontoxic. In addition, oil of spike lavender gives you better control, better adhesion to the surface, and the ability to thin the paint without changing its quality.

Linseed oil is used to create oil paint. You can also use it to thin your paints. You'll find other types of oils in your art store as well, including walnut, poppyseed, safflower, and sunflower.

VARNISH

Varnish will protect your surface from environmental damage. It should be added when the painting is completely dry, which takes at least six months. Some artists choose not to varnish their paintings at all.

OTHER PRODUCTS

There are many more products and materials for oil painting. Here are a few:

A COLOR WHEEL is a roadmap to help you understand the relationships between colors and how they affect one another. (See page 32 for much more about color.)

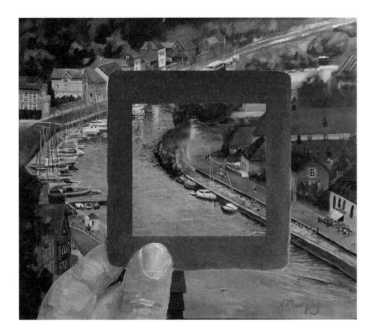

VIEWFINDERS are simple devices that will help you immensely. They are used to help isolate an area, giving you a better feeling for composition and shapes. There are lots of varieties of viewfinders. Some have a movable part that allows you to adjust the size of rectangle or square. Others are divided into thirds to make it easier to construct your composition and measure between areas. It's easy to make one by cutting a square out of a piece of heavy paper. Alternatively, you can use the thumbs and forefingers of both hands to create a square shape to look through.

RED GLASSES help you see the contrast between different areas. They take away the color, enabling you to see dark, medium, and light values.

A MAHL STICK is a long stick with one padded end that is used when painting details on a wet canvas. It. Rest the padded end on the edge of your canvas, hold the plain end with your non-dominant hand, and rest your painting hand on the stick.

Setting Up Your Workspace

"ART IS THE ONLY WAY TO RUN AWAY WITHOUT LEAVING HOME."
—Twyla Tharp, American dancer and choreographer

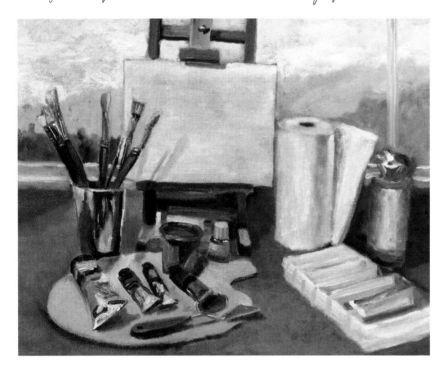

Creating a dedicated space is an important consideration for an artist. You should refrain from setting up at a dining-room or kitchen table—it's important to keep your paints away from food and drink. It's also good to keep your workspace and sleeping space separate, so avoid setting up your workspace in your bedroom. Never smoke in your studio—smoking around solvents is a bad idea because they are flammable.

Set up your art studio in a space where it's easy for you to move around. A desk for your table easel is quite suitable. If you have more space, you can set up a floor easel. A small table next to your desk will come in quite handy for any solvents you might be using.

If you live in a mild climate, think about setting up your studio outdoors. Natural light is ideal for painting. If you live in the northern hemisphere, a studio that has a window facing north is best. If you have a workspace that receives direct light, simply tape tracing paper over the window and you will have instant natural light. Sheer drapes can also mimic this effect.

There are lighting fixtures designed specifically for artists. However, it's not necessary to purchase expensive lighting. Purchase bulbs with CRIs of 80–100. Bulbs emit warm or cool light. Ideally, you'll want a bulb that is in between warm and cool.

Your art studio needs sufficient ventilation because of the paint and solvent fumes. A room with windows on opposite sides will give you cross-ventilation. Consider adding a fan, but point it away from you so that the fumes don't blow toward you.

Keeping a Sketchbook

"IT'S ONLY BY DRAWING OFTEN, DRAWING EVERYTHING, DRAWING INCESSANTLY, THAT ONE FINE DAY YOU DISCOVER TO YOUR SURPRISE THAT YOU HAVE RENDERED SOMETHING IN ITS TRUE CHARACTER."

—Camille Pissarro, Danish/French painter

Drawing is basic to painting. Keep a sketchpad to work on your drawing skills.

When sketching, show the structure and the masses first before working on any details. Perfect drawing is not the goal. Sometimes, when something isn't quite perfect, it will reveal the character of an object or scene. Your drawings will show your individuality.

Jot down notes about color schemes that you see around you. You might use those ideas in future paintings. Do your sketches in one sitting. They could be just a few lines to show shapes and forms. Notice what captures your eye first. Keep things simple.

Use your fingers to create a frame, or use a viewfinder to see the area that you want to sketch. Concentrate on that area.

When you don't have your sketchbook with you, draw with your eyes. A painter constantly studies objects. One area that can frustrate beginning painters is choosing a subject. Observing the shapes around you will help you when you select your subject. You will decide what to leave in and what to leave out.

One of the beautiful things about keeping a sketchbook is that you become mindful of your environment. It can be like seeing a familiar place with new eyes.

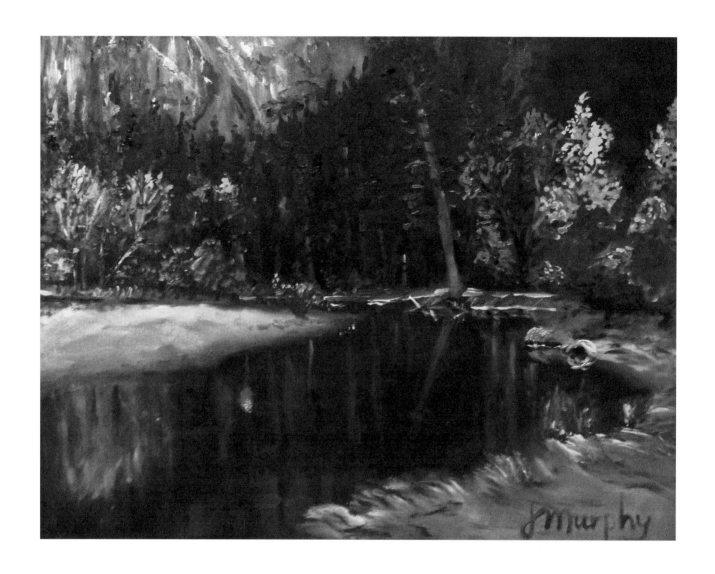

TAKING CARE OF YOUR FINISHED ART

- Don't expose your painting to direct sunlight. It will fade the paint over time.

- Keep your painting in an area with a constant temperature. Don't hang it near a door or window you often open.

- Use a soft cloth to dust your painting.

MATERIALS CHECKLIST

TUBES OF PAINT

The lessons in this book are demonstrated using the following colors. If you find a good set of paints, you can use those colors in lieu of the paints listed below.

☐ Titanium white

☐ Cadmium yellow light

☐ Cadmium yellow dark

☐ Yellow ochre

☐ Cadmium orange

☐ Cadmium red light

☐ Alizarin crimson

☐ Quinacridone magenta

☐ Dioxazine purple

☐ Ultramarine blue

☐ Phthalo blue

☐ Phthalo green

☐ Chrome oxide green

BRUSHES

You will need a few sizes and shapes.

☐ 2" wide flat brush for laying on base color

☐ Flat and filbert brushes in several sizes

☐ Round brushes in several sizes

SURFACES

☐ 9" x 12" pad of canvas paper

☐ Stretched cotton canvas or cotton panels

☐ Hardboard panels

EASEL

☐ Portable or table easel

PALETTE

☐ Wood, plastic, glass, or paper

OTHER MATERIALS

☐ Palette knife

☐ Color wheel

☐ Thinners

☐ Jars

☐ Pencils

☐ Rags

☐ Old T-shirt or apron

☐ Masking tape

ALL ABOUT

Color

Color Essentials

Language is a means to express thoughts and feelings. Artists of all levels and disciplines study color and use its language to create works of art. As you study color, your eye will become more sensitive. Be aware of where the light comes from during different times of day and how it hits an object.

A basic knowledge of color theory is important. Training and using your vision is more important. Study color relationships in nature. Training your vision and knowledge of color will help you create paintings with interest. As a beginning painter, all you need to know can be found on the color wheel.

THE COLOR WHEEL

The color wheel is your roadmap for understanding relationships between colors and how they affect one another. Professional and amateur artists alike use the color wheel as a reference tool. You can buy an inexpensive color wheel at your art store or online for help with mixing colors. You can also make your own color wheel from your paints. Let's start with the basics.

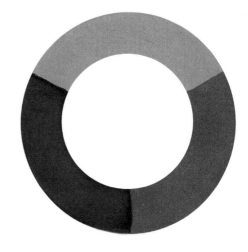

PRIMARY COLORS

Yellow, red, and blue are the primary colors. Primary colors can't be mixed from any other colors.

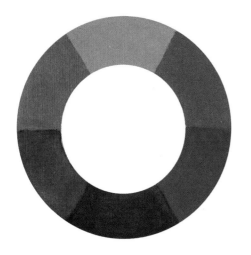

SECONDARY COLORS

When two primary colors are mixed with each other, they form a secondary color. Red and yellow combine to make orange. Blue and yellow combine to create green, and so on.

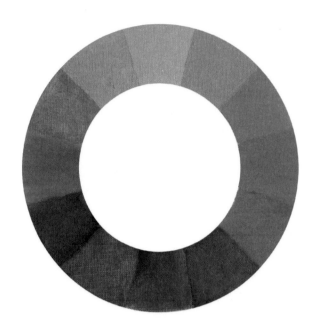

TERTIARY COLORS

Mixing a primary color with a secondary color next to it on the color wheel creates a tertiary color. An example of a tertiary color is when yellow is mixed with orange to create yellow-orange.

COMPLEMENTARY COLORS

Colors that lie directly across the color wheel from one another are called "complementary colors"; this pair has no colors in common. They create the strongest possible contrast. The complementary color for orange is blue. Because the color orange is comprised of the primary colors red and yellow, there is no blue in orange, and so orange wants to complete what's missing. When blue and orange combine, all of the primary colors are present. This occurs in every set of complementary colors. When a color and its complement are side by side, each livens up the other. When they are mixed together, they neutralize each other.

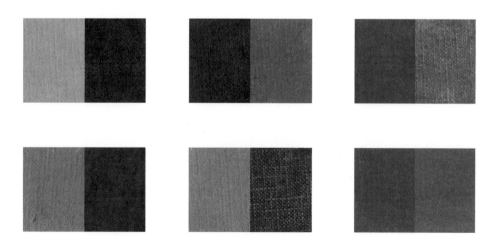

Color Harmony

As a painter, you need to understand some basic color principles. Allow the color wheel to guide you.

ANALOGOUS COLORS

Analogous colors sit next to each other on the color wheel. These colors can be used together to achieve harmonious results. Adding the dark and light values of these colors will give your painting depth.

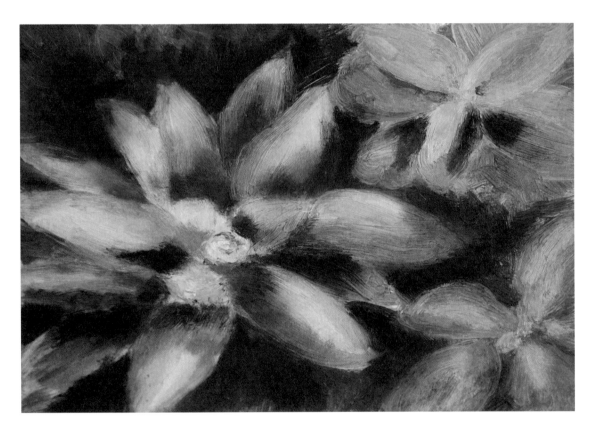

The three adjacent colors in this example are yellow, yellow-green, and green. The colors across the color wheel are their complements. Those colors are violet, red-violet, and red. Mixing the complements into the pure hue will give you neutral colors. Painting this mixture into the shadows will add depth.

COMPLEMENTARY COLORS

A complementary color scheme will help to bring balance to your painting. Choose one of the two colors to dominate the overall painting. Use value and intensity to show shadows and highlights.

TRIADS

The three colors that make up a triad are equidistant on the color wheel. On a 12-step color wheel, every fourth color is part of a triad. The primary colors are a triad. Orange, violet, and green are triads. Because these colors don't all share the same family, they can be brought into harmony by mixing a little of one into the other, so that they share a color. With this technique, your paintings will have a more unified feel. Here are the triad combinations on a 12-step color wheel.

RED	RED-ORANGE	ORANGE	YELLOW-ORANGE
YELLOW	YELLOW-GREEN	GREEN	BLUE-GREEN
BLUE	BLUE-VIOLET	VIOLET	RED-VIOLET

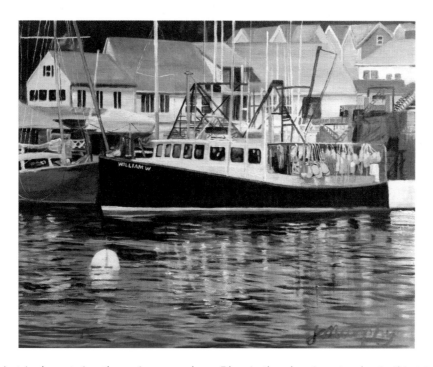

This triad contains the primary colors. Blue is the dominant color in this triad.

SPLIT COMPLEMENTS

A split complement is also made up of three hues. Look at the color wheel to find a complementary pair. They are located directly across the color wheel from one another. Then move one step to the right of the complementary hue and one step to the left of that same hue.

COLOR TEMPERATURES

The color wheel is divided into two sections. On one side are the warm colors, which consist of yellow through red-violet. The cool colors of yellow-green through violet are found on the other side of the color wheel. Complementary colors always have a warm and a cool color in the pair.

Warm colors can be used to give the impression of summer. Winter scenes consist of predominantly cool colors. You will use color temperature when determining the mood of your painting. (See page 108.) Use warm colors when you want to show where light strikes an object. Use cool colors to suggest distance and shadows. Color balance is the relationship between warm and cool.

WARM COLORS	COOL COLORS
RED	GREEN
YELLOW	VIOLET
ORANGE	BLUE

THREE PROPERTIES OF COLOR

There are three properties of color: hue, intensity, and value.

HUE is simply another word for a color. An endless number of hues can be created from the three primary colors of yellow, red, and blue.

INTENSITY is the brightness or dullness of a color. Look at the color wheel to see that the brightest intensity is the pure color on the color wheel. You can change the intensity by adding its complement and/or white. Use intensity to change the mood of your painting. Areas receiving light are usually more intense than objects in the shadow.

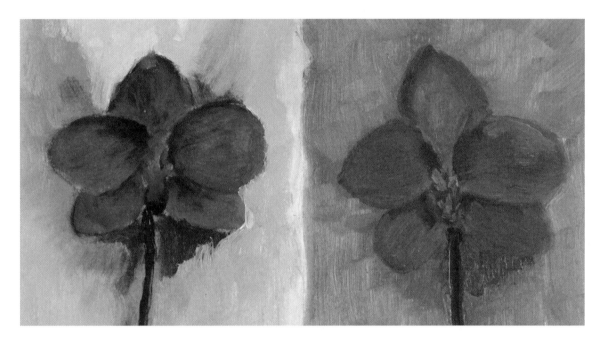

The flower on the left has pure colors of red-violet, violet, and yellow-green. The flower on the right contains the same colors. It has a duller intensity because complementary colors were mixed with the full-intensity colors.

VALUE completes the three properties of color. Value is the term used for the lightness or darkness of a color. Through value, you can tell a light blue from a dark blue. Changing the value doesn't change the color. The dark blue you mixed will always be blue. Value can help turn a two-dimensional surface into a three-dimensional image by using light and dark to create form.

Tints and shades are common terms for varying value. A tint is a light value created by adding white to a hue. A shade is a dark value and uses the complementary color or black to darken the hue.

Intensity and value can be confusing because there are some similarities. All colors have a value. The pure color yellow has a lighter value than the pure color violet. When the intensity of a color changes, the value also changes.

THE PSYCHOLOGY OF COLOR

We are surrounded by color. It touches our senses and speaks to our emotions. Bright, sunny days can cheer us up. Gray days can bring us down or make us feel somber. Being outdoors in a green forest can bring on a deep feeling of peace. On game day, our colors show support for our team. Advertisers and marketers know how to use color to their advantage.

This table shows some basic meanings we associate with different colors. Note that these meanings are for the pure hue. For example, changing yellow by adding its complement, violet, can change how people react to it. Adding violet will make the pure yellow dull, which, in turn, changes a viewer's impression.

Let's take a trip around the color wheel.

HUE	SYMBOLISM	FUN FACTS
YELLOW	• Happiness • Joy • Intellect • Enlightenment • Wisdom • Warmth • Spring • Cowardice • Hazard • Illness	• The eye processes yellow first. It's often used in cautionary signage, such as a yield sign. • The yellow in a stoplight cautions us to slow down. • A "yellow card" in soccer is a warning.
ORANGE	• Extrovertedness • Energy • Optimism • Spontaneity • Adventure • Youthfulness • Inexpensive • Superficiality • Loudness	• Orange takes the heat and vitality of red and combines it with the sunshine of yellow. • Orange is known to stimulate the appetite. Restaurants often use orange—from a peach color to earth tones—in their décor. The color orange encourages people to eat, drink, and enjoy themselves.

HUE	SYMBOLISM	FUN FACTS
RED	• Energy • Passion • Action • Love • Anger • Aggression • Danger • War	• Red calls attention. It is highly visible. Think of a stop sign. It's interesting to note that many countries' flags feature red as one of their colors. • A "red-letter day" is a special day. • To "see red" means that one is furious.
VIOLET	• Royalty • Rich • Ceremony • Creativity • Courage • Magic • Death • Mourning • Unrest	• Violet is the most difficult color for the eye to pick up, because it has the shortest wavelength in the light spectrum. • Richard Wagner surrounded himself with violet when composing operas. • Violet is said to be an appetite suppressant. It's a rare color in natural foods.
BLUE	• Depth • Stability • Calm • Trust • Serenity • Loyalty • Sadness • Coldness	• Blue is nature's color for water and the sky. • Blue, like violet, is said to be an appetite suppressant. It's also a rare color in natural foods. • Blue ranks high as a favorite color and is often used in business communications and logos.
GREEN	• Life • Nature • Renewal • Soothing • Healing • Greed • Jealousy	• Green is a dominant color in nature and a relaxing color to view. • Green symbolizes ecology and the environment. It is used to advertise "green" products.

THE 7-STEP VALUE SCALE

A value scale exercise for an artist is like musical scales for a pianist. Start with black and white, because it's easier to see their changes in value. Measure the hue's value against the gray scale. Repeat this exercise with different colors, and save them for future reference.

There is no right or wrong number of steps when you create a value scale. It's good to have an odd number of steps, however, so that you can more easily find the middle value. The values from top to bottom will be white, low light, high light, middle, low dark, high dark, and black.

Paint a square of white paint at the top of your paper canvas, and then paint a square of black paint at the bottom.

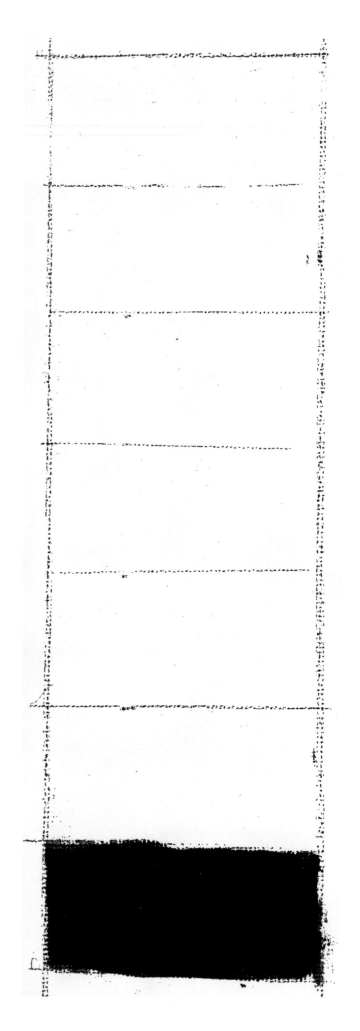

Use a palette knife to mix black into the white paint to find the middle value. Use a brush or palette knife to place the middle value into the scale.

Then create the low light and high light values. Finally, create the low dark and high dark values.

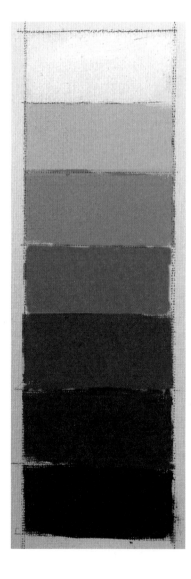

tip

MOUNT YOUR VALUE SCALE ONTO A MAT BOARD OR HEAVY PAPER TO KEEP IT AS A REFERENCE.

Mixing Colors

You could buy a rainbow of different hues, but sometimes having too many colors to choose from can be a hindrance. You will find that your experiments with actual paints will be brighter and truer than any reproduction. Save your money and learn the benefits of mixing your own colors. Plus, it's fun!

MIXING TINTS, SHADES, AND TONES CREATE DIFFERENT VALUES. VALUE GIVES AN OBJECT A THREE-DIMENSIONAL QUALITY.

TINTS

Tints are most often used in highlighted areas of a painting. There are several ways to create tints. You can start with a larger amount of white paint, and then take a small amount of the color you want to make into a tint. Dilute your paint with thinner if you're using regular oil paints, or thin with water if you're using water-soluble oil paints. The more paint thinner you add, the lighter the tint will become, and you'll see more of the canvas.

Mixing cadmium yellow light with cadmium red light creates a third color in the middle.

SHADES

Use a color's complement to darken the color. Start with a larger amount of the color that you want to adjust. Add small amounts of its complement to get the shade you want. As you add more of the complementary color, the paint color will become more and more gray.

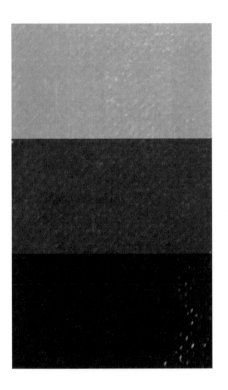 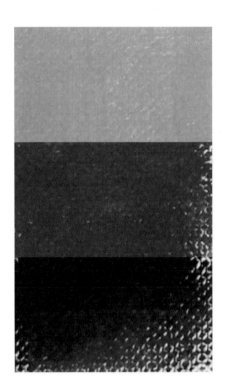

Yellow mixed with black creates a greenish color (left). On the right side, yellow mixed with its complement creates a neutralized color.

TONES

A tone adjusts the value and intensity of a color. To create a tone, start with a hue, and add its complement to create a shade. Once you have the shade you want, add white and you'll have a tone. Tones can be used in highlighted areas of a painting.

CREATING BLACKS & GRAYS

You can buy a tube of black oil paint, but the richest blacks and grays don't come out of tubes. Mixing a bright yellow with black paint from a tube can actually turn it into a muddy mess. There are infinite possibilities for creating grays when mixing paints. Use complementary colors to create grays, or neutralized colors. Once you have a black mix, add white to change its value.

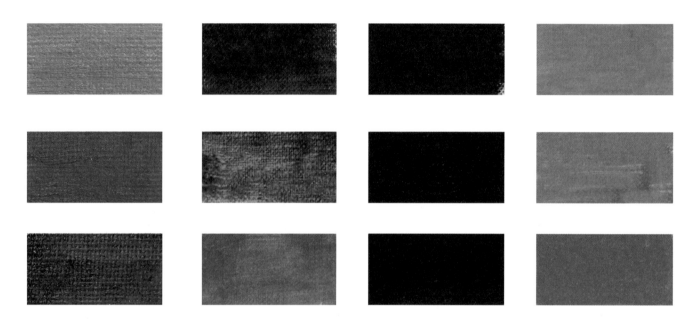

The primary colors, blue, red, and yellow, are in the left column. Their complements are next to them in the second column. They combine to create a rich black in the third column. Adding white to the black mixture creates a rich gray in the fourth column.

Yellow and violet are mixed together to create black. White is added to change the value to a violet-gray.

To neutralize red, add small amounts of green. Add white to change the value.

Blue and orange are mixed together. Add white to change the value.

tip

ANOTHER WAY TO MIX BLACK AND GRAY IS TO COMBINE ALL THREE PRIMARY COLORS. EXPERIMENT WITH DIFFERENT AMOUNTS OF YELLOW, RED, AND BLUE. TRY ADDING WHITE TO THE MIXTURE.

EARTH TONES

Earth tones are less expensive colors of oil paint because the pigment comes from ground earth. It can be convenient to buy these colors in tubes, but mixing your own colors is another option that will help you in your study of color.

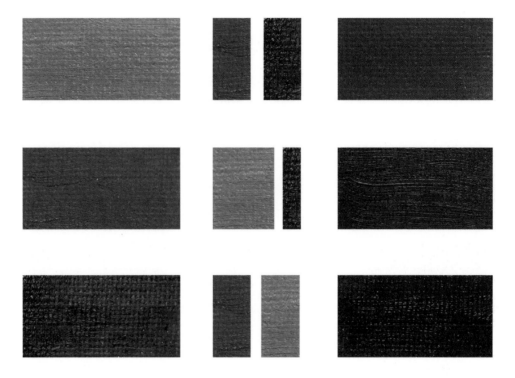

Earth tones include all three primary colors: yellow, red, and blue. One of the primary colors will dominate.

YELLOW OCHRE	Yellow is the dominant color in yellow ochre. Mix small and equal amounts of red and blue. Mix them with a larger amount of yellow. Play around with creating yellow ochre.
BURNT SIENNA	Red is the dominant color in burnt sienna. Mix red and yellow to create orange. Add a small amount of blue to this mixture. Add more blue as needed.
BURNT UMBER	Blue is the dominant color in burnt umber. Mix red and blue to create violet. Add a smaller amount of yellow to this mixture to create burnt umber.

Matching Colors

Experimenting with mixing colors helps you learn how to get the color you want.

MATERIALS NEEDED

- [] Color wheel
- [] Paint swatches/chips from a hardware or home-improvement store
- [] Pencil
- [] Oil paints
- [] Paper canvas
- [] Flat brush

Choose a paint chip, and paste it on a piece of paper canvas. Using a pencil, draw a similar-size box directly under the paint chip.

Use the color wheel to determine which hue is closest to the paint chip. Then use the hue's complementary color (directly across from it on the color wheel) to create a shade. Creating a shade will change the intensity of the color. Use a tiny amount of the complement to darken the color. Adding more of the complement darkens the value.

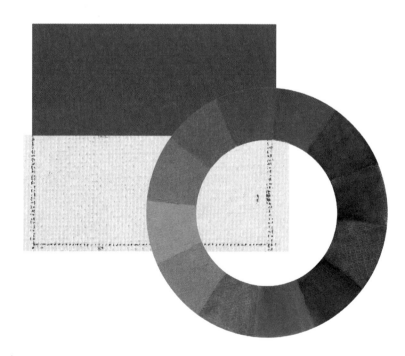

tip

TAKE NOTES ON WHICH COLORS YOU USED TO CREATE ANOTHER COLOR. YOU CAN REFER TO THESE LATER WHEN YOU BEGIN A NEW PAINTING.

Adding white creates a tone. However, the color you choose might only need some white added to create a tint of the color.

Using Color to Create Three-Dimensionality

Painting fruit is a great way to explore bold colors and how their complements can add vitality. The form of a tomato is a sphere. You can use light and dark values to make the tomato look three-dimensional instead of flat. The form is easily distinguishable using four values: shadow, deep shadow, light, and highlight.

MATERIALS NEEDED

☐ Value scale

☐ Oil paints in red and green

☐ Surface of your choice

☐ Flat brush

☐ A spherical object, such as a tomato or an apple

Spheres are defined by oval and crescent shapes. Local color is the object's actual color without modification by light and shadow. The tomato's local color is red. A light source will shine on the tomato and create a cast shadow and a form shadow. The cast shadow occurs because the object is blocking the light. The cast shadow isn't a solid shape but varies in lightness and darkness. The form shadow is the dark side of the object not facing the light source.

Paint the local color, red, within the tomato's outline, leaving a space for the highlight area. The area just to the right of the shadow area will be lighter than the shadow area.

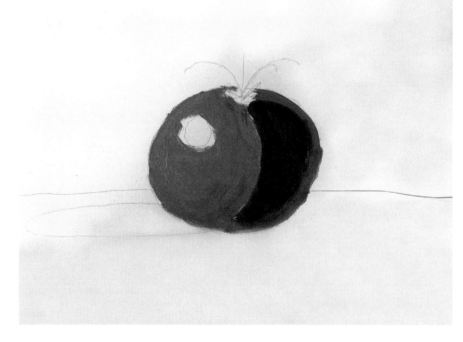

Instead of using black for a shadow, use red's complement, green.

Add a little red and yellow to white for the highlight area. This orange mixture will give the tomato a warmer glow.

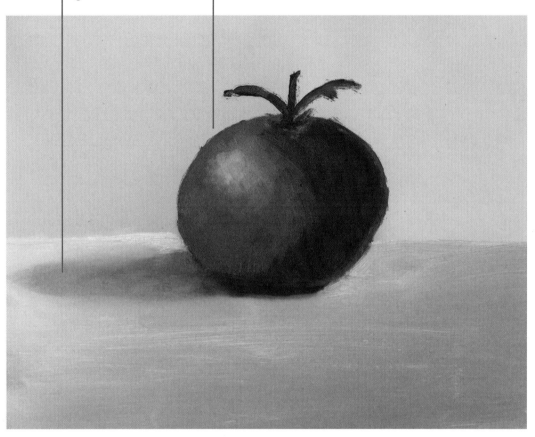

HOW COLORS INTERACT IN PAINTINGS

Take a look at the painting of the tomato. The red and green interact with each other with vibrancy. Imagine if the shadow had been painted black. The effect would be quite dull.

Paint color will look different alone on a palette than when it's relating to the colors around it in a painting. It could look brighter or duller. It could stand out too much or even seem to disappear.

Trust your judgment, and have fun! Now that you've learned some methods to get the colors that you want, be curious. Color lends itself to experimentation, and this will enrich your art *and* your life.

MASTERING
THE
Brush

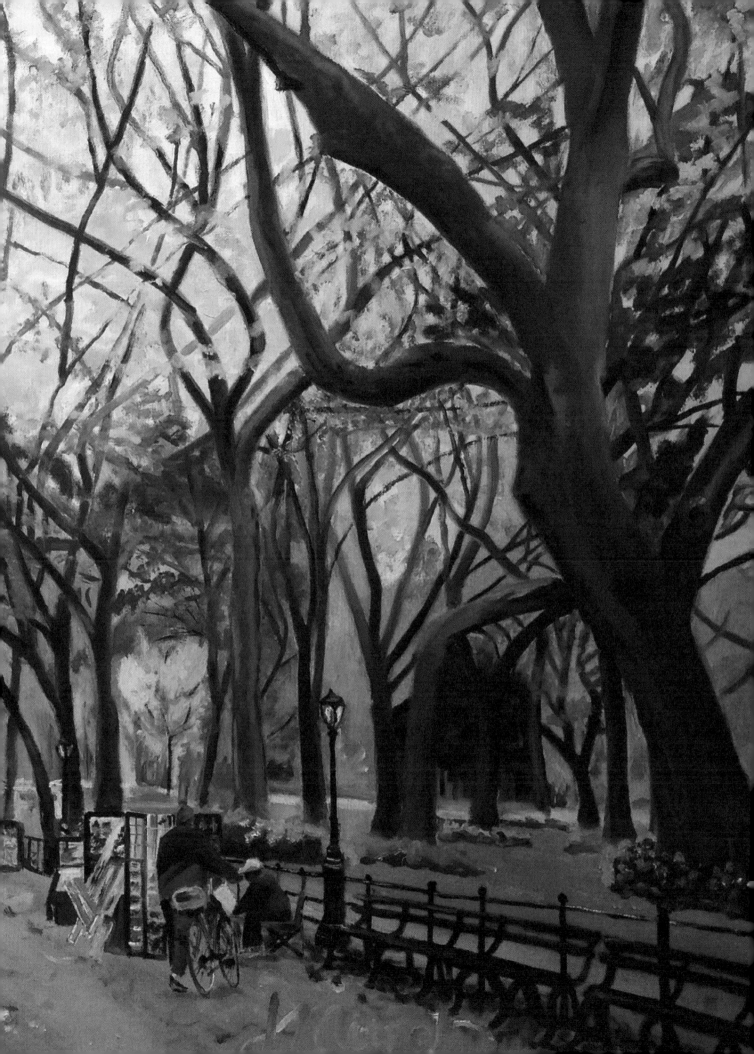

First Things First

Starting to paint can feel daunting, but you can learn techniques that will help you along your way. Even master painters practice their strokes with oil sketches. Practice will eventually help you create a painting that looks free and effortless. Experimentation is also an important part of painting. As you progress, don't be afraid to try new ideas.

HOLDING THE BRUSH

There are different ways to hold your paintbrush. Each will give your painting a different effect. Also, the type of grip you use will vary depending upon the size of your brush. Experiment to see which of the following three grips works best for your painting style.

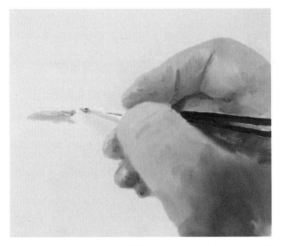

To create fine details, hold your brush gently, like you would a pencil or pen. Grip it close to the bristles. Practice this grip by signing your name in oil paint on a paper canvas.

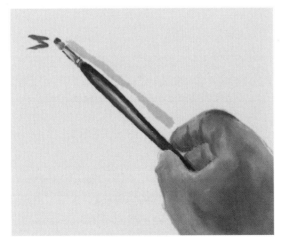

For a looser style of painting, hold your brush toward the bottom, away from the bristles. Hold it as if you're conducting an orchestra with a baton.

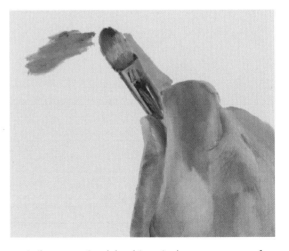

When you're blocking in large areas of color, you'll want to hold your brush with your hand over its top. Hold it parallel to the canvas to quickly apply the paint.

BRUSHSTROKES

The brush and your grip will define the brushstroke.

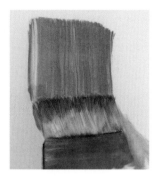

Take a wide, flat brush. Use even pressure to lay down a wide stroke.

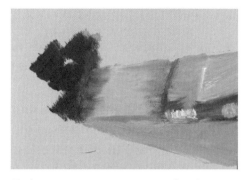

Dab a generous amount of paint onto the canvas using a flat brush.

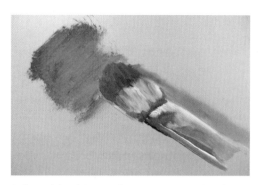

When blocking in large areas of color, use a large bristle brush with a generous amount of paint. Turn the brush parallel to the painting surface, and rub it back and forth in a quick motion.

Use the same wide, flat brush, and turn it to the side. Use even pressure to lay down a thin stroke. This brushstroke can be roughly applied.

Create another thin stroke by using a round brush. Be gentle; too much roughness will splay the bristles.

Painting Techniques

GLAZING

Glazing is a process of applying thin layers of paint on top of one another to give your painting depth and richness. The colors underneath will show through each following layer. Make sure that you let each layer of paint dry for several days before glazing the next layer to avoid cracking. Glazing can be done on the entire painting or just in one area to emphasize it.

Build up color by applying very thin layers of paint. Different mediums will make your paint thinner and help speed up drying time. For best results, glaze on a smooth surface, such as a hardboard panel or fine woven canvas. Use a light or white ground to help with the light reflection of subsequent layers. Paint layers smoothly with a soft brush, and eliminate brush marks by using a fan brush lightly over the surface.

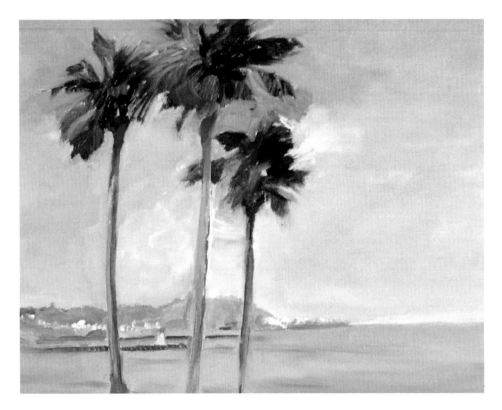

SCUMBLING

The difference between glazing and scumbling is transparency. Glazing uses transparent layers; scumbling uses opaque paint over a dry layer. Scumbling is a great technique to use when painting skies. Light layers are painted over dark layers using little or no medium. The scumbled areas are broken up and uneven, allowing the layer underneath to show through.

STIPPLING

Stippling is another technique used to build color. Using a dry bristle brush filled with paint, tap it quickly onto the painting surface.

IMPASTO

Impasto is a method of painting with thick amounts of paint applied with a brush, a palette knife, or both. Use heavy brushstrokes as well as mediums designed specifically to thicken the paint for impasto. Make certain that your painting surface is sturdy and well supported to handle the large amount of paint.

ALLA PRIMA

Alla prima means "at first" in Italian. It is also called "wet-into-wet," or "direct painting." Use this technique to complete an entire painting in one session without waiting for the layers to dry. Be bold, and use your entire arm for confident strokes. Start with larger brushes, and move to smaller brushes at the end for more detailed work. Use thin paint to start, and build up to thicker layers.

LIGHTING & FORM

Knowing how to create form will turn a flat painting surface into something that looks three-dimensional, showing the height, width, and depth of an object. Basic forms include the sphere, cube, cone, and cylinder. Almost everything we see is comprised of one or more of these forms. The forms might be stretched and/or flattened. A sphere might be squashed into an oval shape, but it is still a sphere. A cube might be elongated into a pizza box, but it's still a cube.

Organic forms occur in nature, but you can break them down into the basic forms. A pine tree is a cone shape with a cylinder-shaped trunk. Take that cylinder-shaped trunk and put an oval on top of it to create an oak tree.

Lighting is critical in creating forms. There are five types of light to consider when creating three-dimensional form.

1. Highlight: The area closest to the light source.

2. Core shadow: The darkest value in the object.

3. Transitional tone: The area between the highlight and the core shadow.

4. Reflected light: An area of reflected light just behind the core shadow.

5. Cast shadow: The shadow created by an object blocking the light.

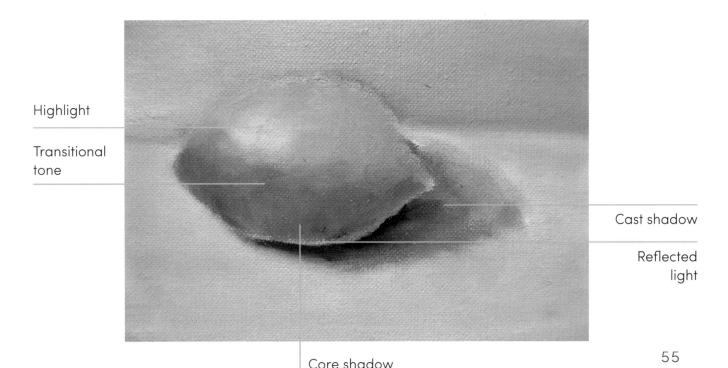

Highlight

Transitional
tone

Cast shadow

Reflected
light

Core shadow

55

Understanding Form

Using black and white paint will give you a better understanding of light and dark value shapes. Then, after you've practiced these forms in black and white, try painting them in color. Note that the light and dark values in the objects create the illusion of three dimensions. For each shape, mix up four values: shadow, deep shadow, light, and highlight. Use the value scale that you created on page 40 as a guide.

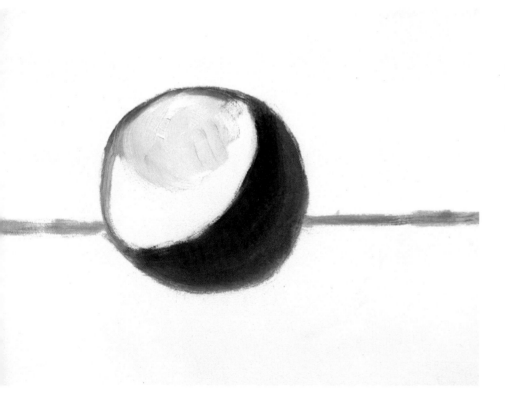

SPHERE

Remember that spheres are made up of crescents and ovals. Reinforce your knowledge of painting spheres by painting one in black and white.

tip

LEARNING TO PAINT WITH THREE DIMENSIONS WILL HELP YOU TURN A FLAT CIRCLE INTO A SPHERE.

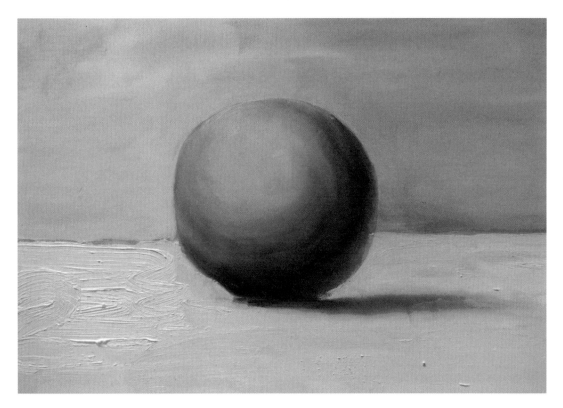

Determine the direction of your light source. Then paint a horizontal line to show a table. Use three distinguishable values to create the sphere: dark shadow, light, and highlight. The dark shadow value will create cast shadows. Place the darkest shadow closest to the object.

tip

USE A DRY BRUSH OR YOUR FINGER TO FEATHER OUT THE SHADOW AS IT MOVES FARTHER AWAY FROM THE SPHERE.

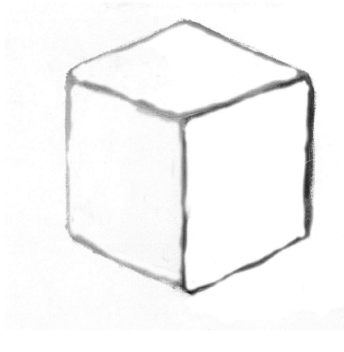

CUBE

Begin by drawing a square. Give it dimension by drawing one side and the top of the cube. Keep the vertical lines straight up and down.

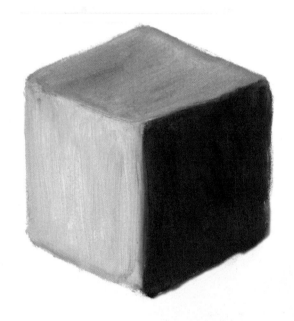

Determine the direction of the light source. Paint this area in a highlight value and the left side in a light value. Paint the right side in a dark value.

Use a deep shadow value to paint the cast shadow. Use your finger or a dry brush to blend the shadow out. You want it to have a blurry edge, not a sharp one.

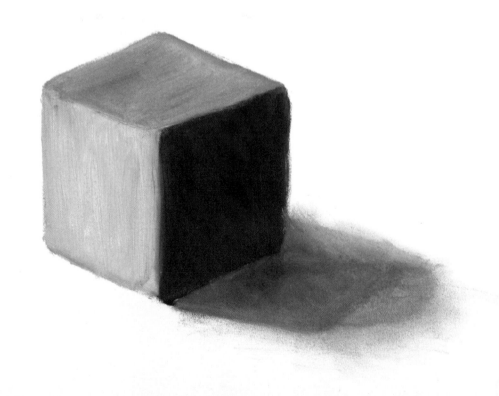

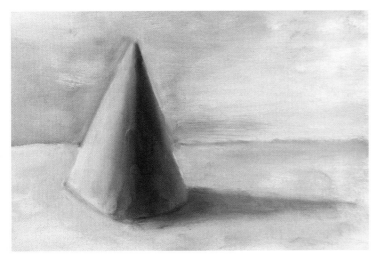

CONE

Cones are defined by triangular values of light and dark. They use the same types of light to define their shape. Determine the direction of your light source. Use a pencil or thinned paint to create a horizontal line for the table. Then create a cone on the table.

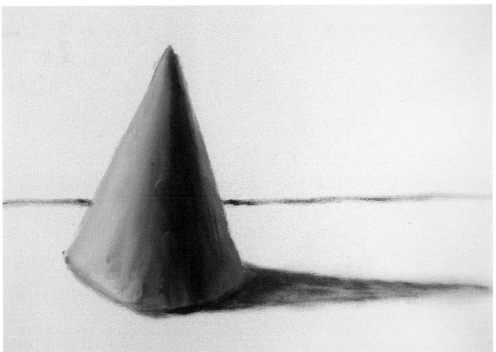

Three to four distinguishable values will define your cone: dark shadow, shadow, light, and highlight. The shadows will be in the shape of a triangle. Once the shadows are painted, blend the areas together.

Use the dark shadow value to create cast shadows. Place the darkest shadow closest to the object. Use a dry brush or your finger to feather out the shadow as it moves away from the sphere.

Play around with the values on the table to give it dimension. Remember that the table itself will have different values. The area closer to the light source will be lighter in value.

Design & Composition

Design and composition can affect the viewer's emotions. Composition is the foundation of your painting and contributes to its success. Every good composition will draw the viewer in and attempt to hold the eyes there for as long as possible. Let your viewer travel through the painting.

CHOOSING A FORMAT

Painting surfaces come in rectangular, square, and oval shapes. Landscape paintings are typically—but not always—horizontal. Tall waterfalls might be better suited to a vertical canvas. A square canvas can work well for an abstract subject. If your subject is a landscape, you might find it easier to learn how to create a good composition using a horizontal, rectangular format.

LINES

Lines relate to one another on the picture plane. Typically, horizontal lines convey peace and contentment. Vertical lines suggest strength and growth. Diagonal lines are dramatic. Subjects can range from peaceful landscapes to turbulent storms.

The person viewing your work will follow the lines in your painting, either consciously or unconsciously. Lead the eyes to a destination in your painting. Where do you want your viewer to end up resting his or her eyes?

It's most common to read a book from left to right. It's also natural to read a painting from left to right. Lead your lines from the left corner to the center of interest. Areas of contrast naturally draw the eye to them.

CONSISTENCY

Your light source should come from the same direction in your painting. When you paint this way, you establish consistency. Otherwise, it will confuse the viewer.

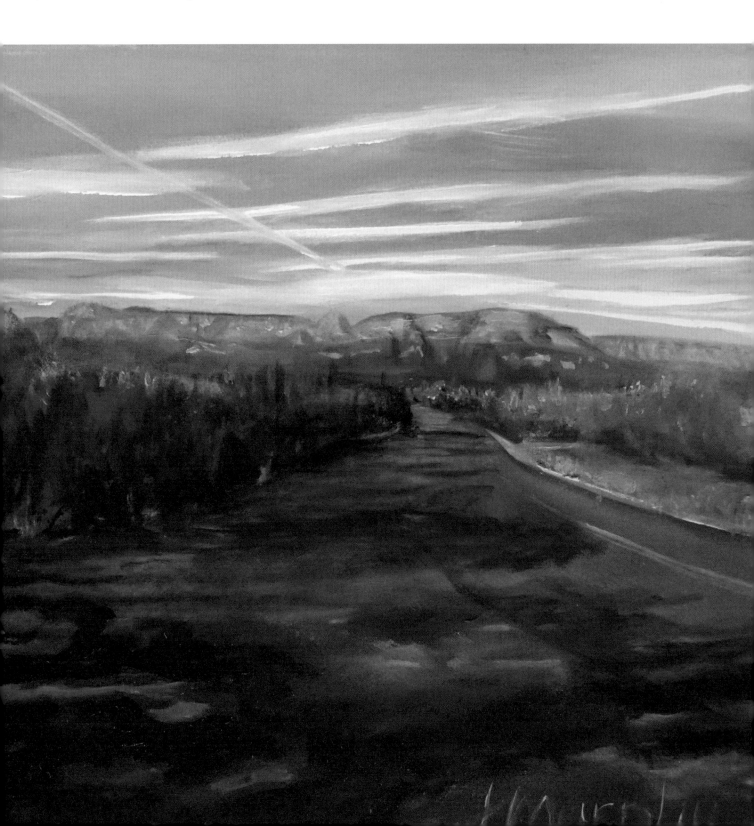

Simplify, Simplify, Simplify

You can simplify a design by breaking your composition down into its main shapes. Block in the main shapes of your composition in a sketchbook. Using your sketch as reference, block in the shapes on your canvas. Begin to differentiate areas by using shadow and highlight colors.

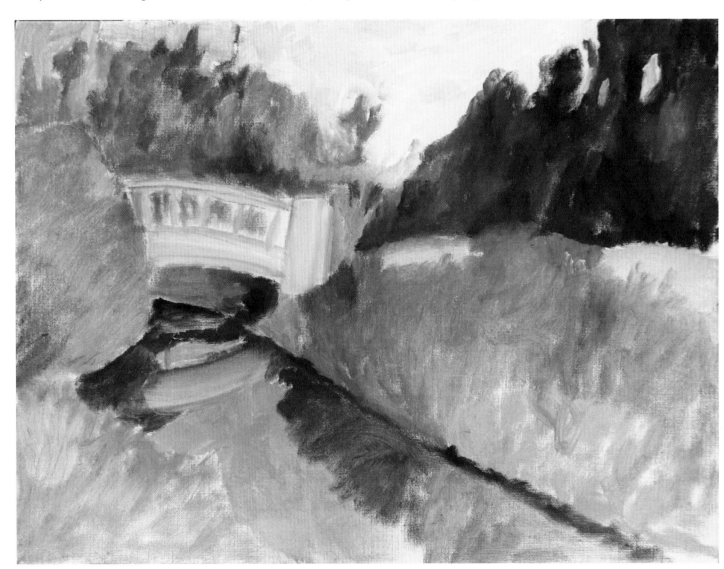

Notice that the lines in the painting lead to the bridge.

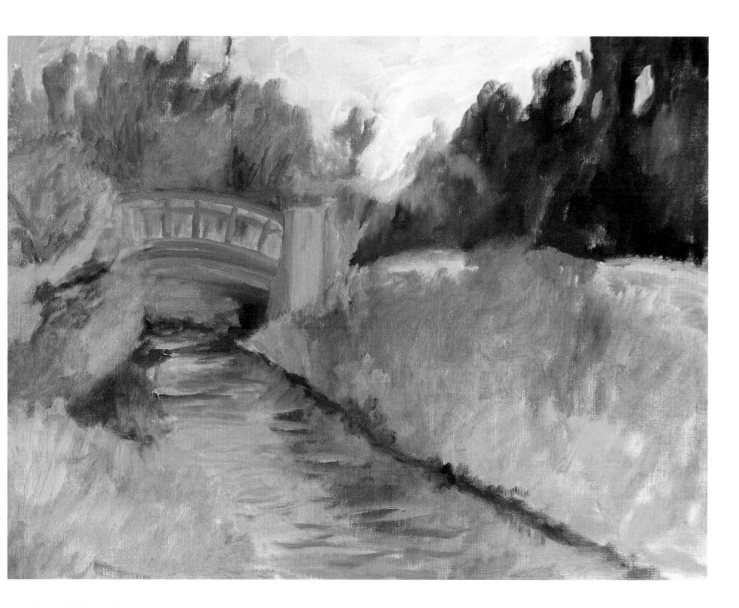

PROPORTION

Creating objects with expressive quality is more important than getting the exact proportions correct. Use size, color, and light to show proportions. Overlapping images can give a sense of proportion.

Adding Interest

CONTRAST

Lead the viewer's eye to the area that you decide is most important by incorporating contrasts. The eye will also be drawn to sharper edges. Think about using sharper edges in areas of interest. Keep the edges in the rest of the painting soft.

Find drama in your painting that will hold the viewer's attention. A dramatic scene will have sharp contrasts. Imagine a stormy violet sky. Everything looks dark and brooding. Then, all of a sudden, you see a streak of yellow-orange where a bit of the sun has shone through.

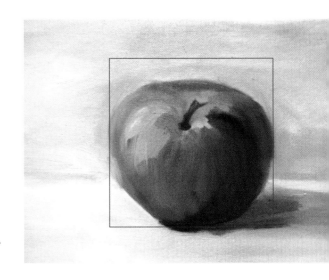

SIMPLICITY

One of the best ways to think about simplicity is to paint a small painting. You will be forced to choose the most important elements and forms to put into it. Painting small will crystallize your composition. If you can paint in this small format and are happy with it, paint the same image with more detail on a larger painting surface.

Another way to simplify is to choose a simpler subject. You might select just a portion of a house and add a cat or a dog. Focus your attention on what you see as the most interesting part of the whole.

tip

TRAIN YOUR EYE TO SEE PROPORTION

Visualize a square around the object that you want to paint. Does the object fit inside of that square? Is the object taller or wider than the square?

PATTERNS

Introducing patterns can make your design more interesting. Use busy patterns along with simple ones in the same painting. The viewer's eye will move to the busy area. Use size, color, and lighting to show which object dominates. Try placing the dominant object on the left or right third of your painting instead of directly in the center.

ODD VS. EVEN NUMBER OF OBJECTS

An odd number of objects in a painting can create a dynamic and lively feeling. Sometimes an even number of objects looks static or even boring.

FOCAL POINT

The focal point is the area of interest. Consider where you want the focal point to be in your painting. What do you want the viewer to focus on? Use the rule of thirds to find the path to your focal point.

The Rule of Thirds

The rule of thirds separates the picture plane into three sections vertically and three sections horizontally. This rule is actually more of a guideline. Use common sense, and apply the rule of thirds to create a good composition.

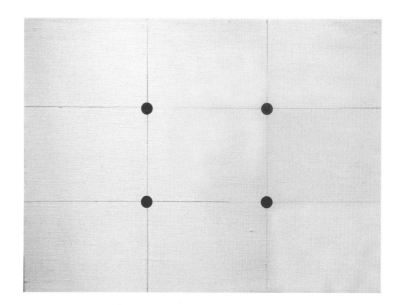

The focal points can be found at the points of intersection of the horizontal and vertical lines. Splitting a painting in half horizontally or vertically will often cause it to look flat. Take care when objects start gravitating to the middle of your painting surface. Remember that you are painting a visual story. Using the rule of thirds will help improve the design and composition of your paintings.

tip

A LANDSCAPE PAINTING CONTAINS THREE DISTINCT AREAS: THE FOREGROUND, THE MIDDLE GROUND, AND THE BACKGROUND. AS OBJECTS RECEDE INTO THE BACKGROUND, THEY LOSE DETAIL.

PAINTING WITH THE RULE OF THIRDS

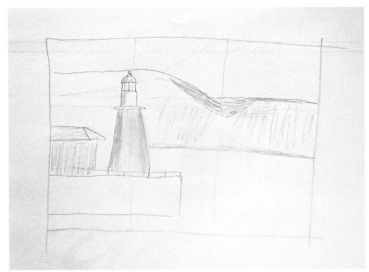

Take your sketchbook, and draw a lighthouse in the center of the paper. This lighthouse uses the cylinder form as the main base. A smaller cylinder form is placed on top for the light. There is a bluff and a horizon line.

Use a pencil to create three horizontal sections and three vertical sections. Remember that the hotspots lie in the intersection of these lines. Choose one of these hotspots for the main focus of your painting.

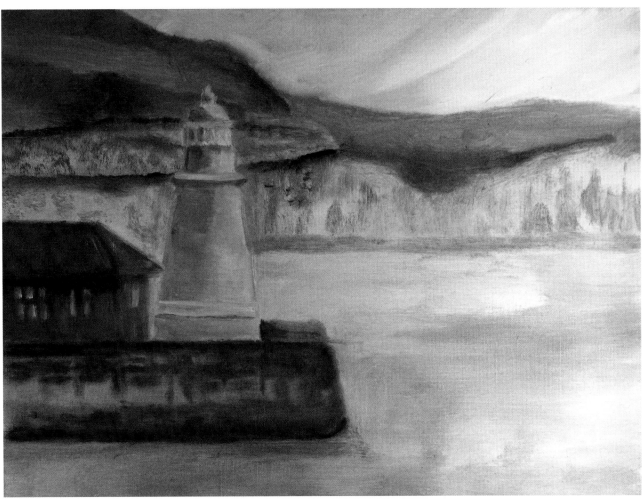

Use thinned oil paint to sketch in the composition. Place the lighthouse near the vertical line. The top portion of the lighthouse will fall on or near the hotspot. Block in the bluff, the ocean, and the sky. Create a horizon line. Block in the main forms. Add details, and use your knowledge of cylinders to give the lighthouse form.

The Figure in Landscapes

Our eyes are drawn to living things. Even small figures in a painting can overpower larger masses. A figure can be human or animal. When figures are placed in a landscape painting, weather, light, and time of day all contribute to how you will paint the figures.

It's best to plan figures in your initial composition instead of adding them as an afterthought. Placing figures in a painting can give the viewer a sense of scale of the surrounding landscape.

SOLITARY FIGURE VS. A GROUP

A solitary figure will affect the mood of your painting.

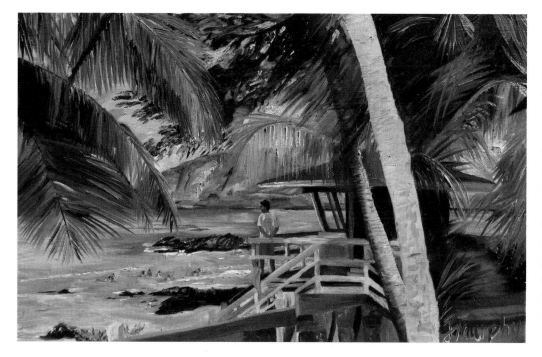

The figures here consist of splashes of color and quick strokes. They are treated as a whole while the lifeguard looks on. The viewer makes the leap that they are swimmers. The lifeguard is a single figure, yet he relates to the group. The group of swimmers has a relationship with the environment.

tip

TREAT GROUPS OF FIGURES AS MASSES. PLACE THE FIGURES IN A LOGICAL RELATIONSHIP TO ONE ANOTHER. IF THERE ARE MANY FIGURES, COMBINE THEM UNLESS YOU WANT AN OBVIOUS DISTINCTION. WHEN YOUR FIGURES ARE ON A FLAT TERRAIN, THEIR HEADS WILL BE ON A SIMILAR HORIZONTAL LINE.

Figures in landscapes typically show less detail than in a formal portrait. The pose, action, mass, and color are most important when painting figures. The idea is to simplify the figures instead of showing a lot of detail.

Figures are affected by the light source. Include the cast shadows of figures. Make sure that the lighting hits the figures in the same direction as the other objects.

PEOPLE

People and animals are composed of forms. Look for spheres and cylinders in various shapes and sizes.

Start by learning basic proportions for the human body. The top of the hips is the point that divides the body in half. The measurement from the top of the head to the top of the hip is generally one-half of the entire body. The measurement from the top of the hip to the bottom of the foot makes up the other half.

Think of the figure as a composite of different forms: the sphere, cube, cylinder, and cone.

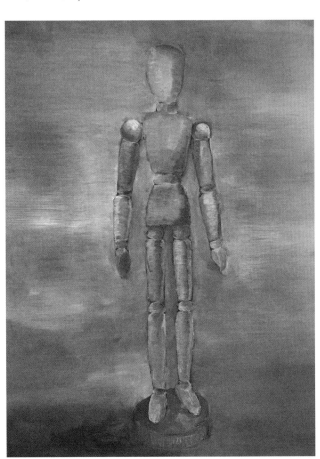

1. The head is a sphere in the form of an egg.
2. The neck is a cylinder.
3. The torso is made up of two cone shapes. One cone is upside down. The other cone is right side up. They are connected by a sphere, which becomes the waist.
4. The shoulder and elbow are spheres. They are connected by a cylinder shape, which becomes the upper arm.
5. The elbow is even with the waist.
6. The wrist is even with the hips.
7. The elbow and wrist are connected by a cylinder shape, which becomes the forearm.
8. The hips, knees, ankles, and feet are sphere shapes. They are connected by cylinder shapes, which in turn become the legs.
9. The knee is lower than the tips of the fingers.
10. The entire lower body from the hip to the bottom of the foot is one-half of the figure.

Painting with a Few Strokes

Sketch these figures, and then paint them in a few brushstrokes. When drawing each of the following, start with the body shape to keep in mind the proportions of the other elements of the body.

SITTING

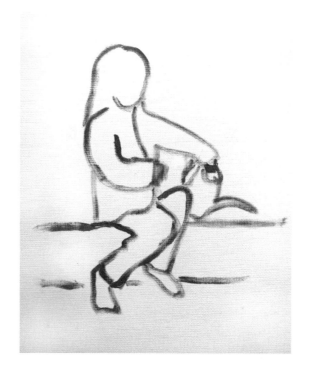

WALKING AWAY

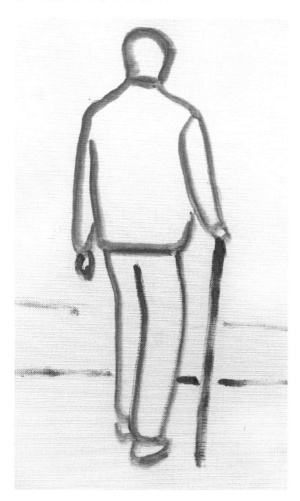

BICYCLING

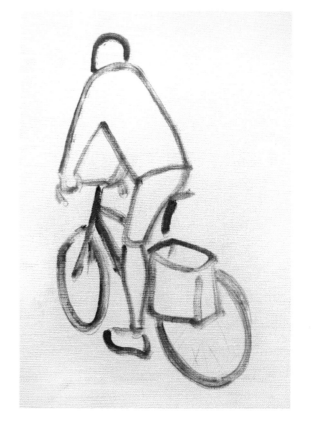

GROUPS OF FIGURES

Treat groups of people as a whole. Paint them in relationship to one another. Simplify the lines and shapes, and create a sense of movement.

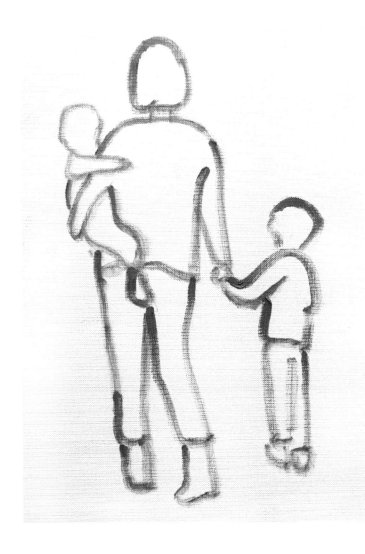

tip

WHEN PAINTING A HEAD, BEGIN BY MAKING IT SMALLER THAN THE REST OF THE FIGURE. YOU CAN ALWAYS MAKE THE HEAD LARGER.

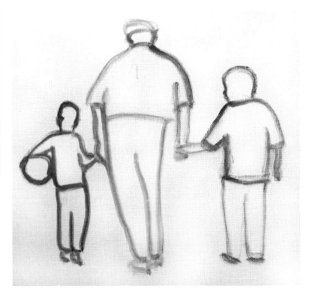

ANIMALS

Animals come in all shapes and sizes. Do you have an animal at home? If so, you have the perfect opportunity to draw and paint your pet in the comfort of your home. Pets give an endless number of possibilities for poses. You'll find a perfect opportunity to study, draw, and paint when your pet is sleeping.

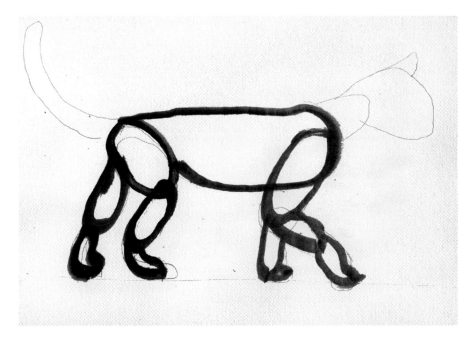

Use spherical and cylindrical forms to create a cat. Use simple lines to convey the cat's shape. Use elongated spheres to create the back and front legs. The cat's body is also a sphere.

Use a cylinder for the neck. The head will be another sphere shape. Create an ear using a cone shape. The last piece is the tail of the cat. Fill in the lines to give the shape of the cat.

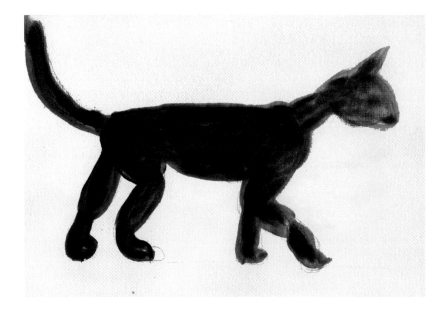

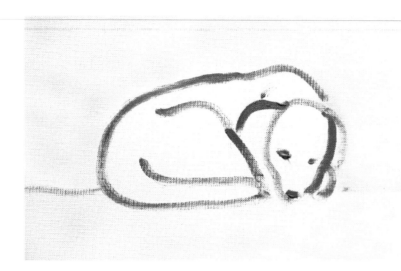

When you want to put animals into your landscape, you can paint them in a few strokes. If you plan to put a background behind your subject, think about keeping it simple.

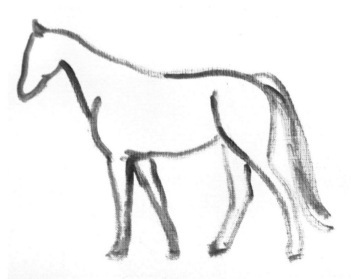

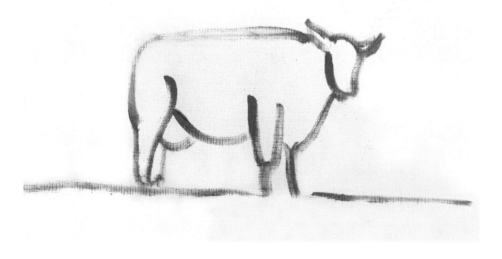

Your landscape might have groups of animals in a field. Treat all of the individual animals as a whole composition. Paint the group and how the individuals relate to one another. If you are painting very small birds, use even simpler marks than those described here.

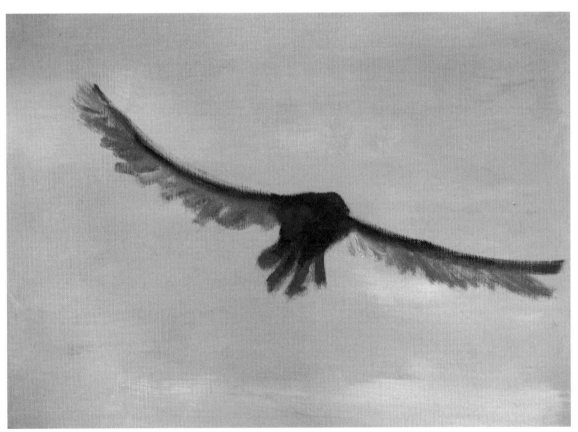

Create a sphere for the hawk's head. Paint upward lines for the hawk's wings. Then make an upside-down cone shape for the hawk's body.

BIRDS & THEIR SURROUNDINGS.

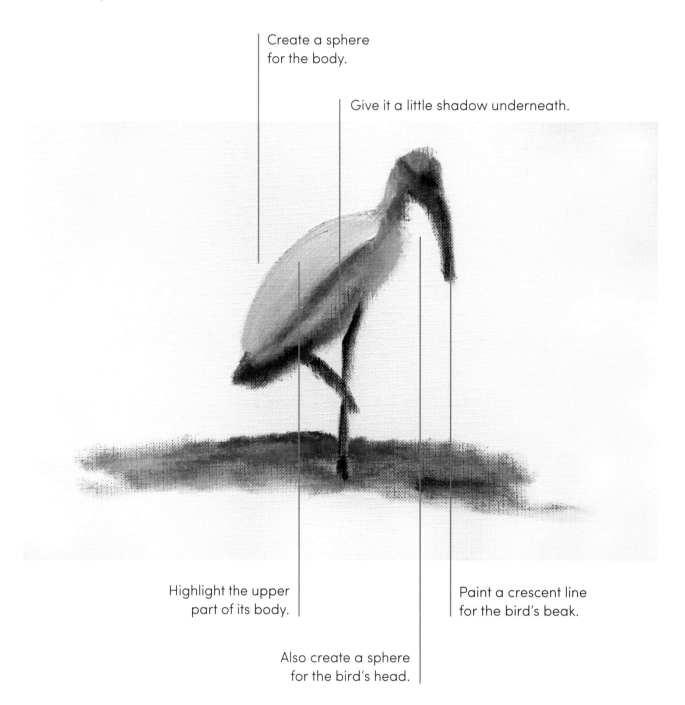

Create a sphere
for the body.

Give it a little shadow underneath.

Highlight the upper
part of its body.

Paint a crescent line
for the bird's beak.

Also create a sphere
for the bird's head.

Create a sphere
for the duck's
head.

Paint a line for the
feathers.

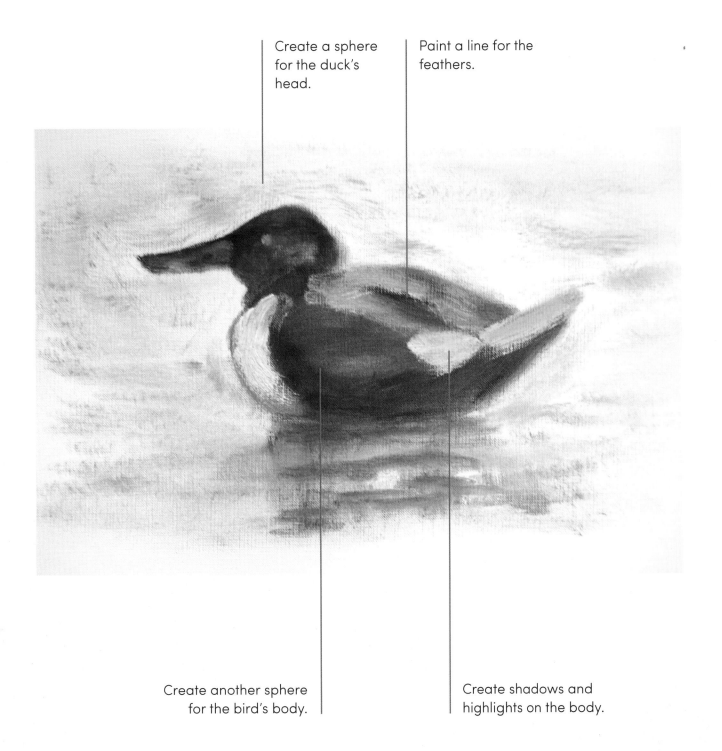

Create another sphere
for the bird's body.

Create shadows and
highlights on the body.

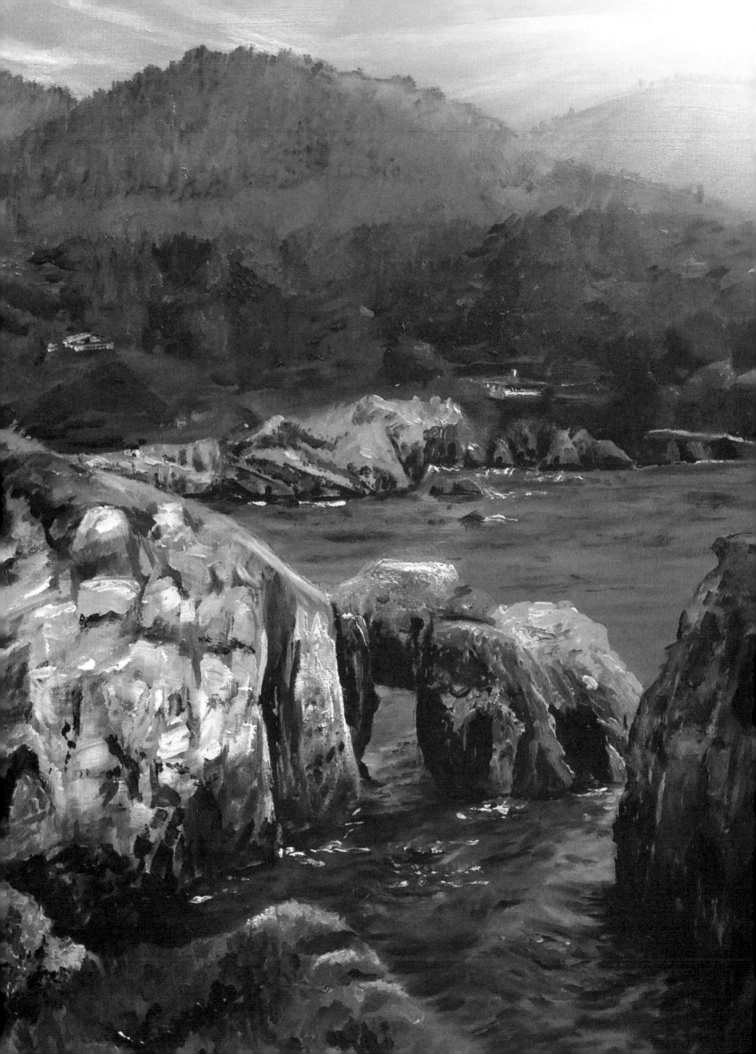

Land
&
Water

Landscapes

A landscape painting is generally done on a horizontal painting surface parallel to the earth. There is a sense of peace in this type of landscape, a feeling of being earthbound or tied to the elements of the earth. If you want to express a sense of calm, keep your lines horizontal. However, you can create more depth by bringing vertical and diagonal lines into your painting. Vertical lines in a landscape communicate stability, strength, spirituality, height, and grandeur. Vertical lines pull our eyes up to the sky and to places beyond the human reach.

tip

SPIRAL LINES GIVE THE SENSE OF INFINITY. THEY ARE GRACEFUL AND FEMININE, WHILE ZIGZAG LINES CONVEY CHAOS.

HIGH MOUNTAINS

High, craggy mountains are bare at the top. Rock and snow are found at these high elevations. Forests lead up to the high mountains. These mountains are farther away, so they will feature fewer details.

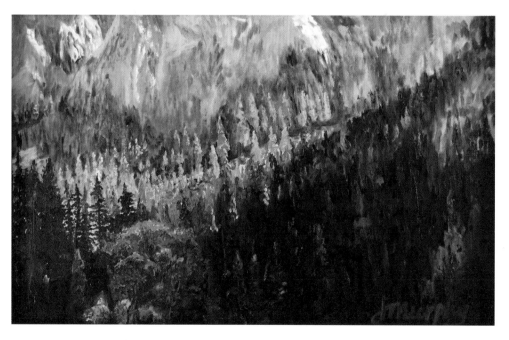

The diagonal line of the row of trees leads the viewer's eyes to the focal point that is the orange tree. This diagonal line creates energy and drama. The mountains in the background serve as a strong vertical.

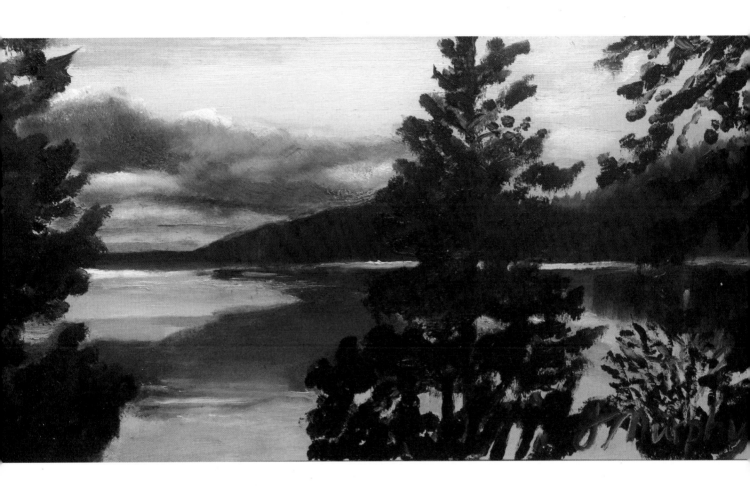

TREES

When leaves are falling or a tree is completely bare, there are often strong vertical and diagonal lines. Evergreen trees are typically darker in value. Deciduous trees are usually lighter in value and reflect more light.

Vertical Lines & Trees

Trees can create strong vertical bands that add drama and interest to a painting.

MATERIALS NEEDED

- ☐ Oil paints in warm gray, green, yellow, and red
- ☐ Small synthetic or sable round brushes
- ☐ Paper canvas or your sketchbook
- ☐ Rags

Discern the dominant line of growth. Paint the trunk of the tree and a few branches. Trees are usually not entirely straight up and down; a leaning tree can be more interesting. The trunk and the thicker limbs should be darker than the smaller branches.

Start splitting smaller branches off of main branches. Some branches will grow upward, some branches grow to the side, and others take a downward turn. Begin adding foliage by dabbing green into the branches.

tip

THIS WINTER SKELETON OF A TREE FORMS THE BASIS FOR OTHER TREES THAT YOU MAY WANT TO PAINT.

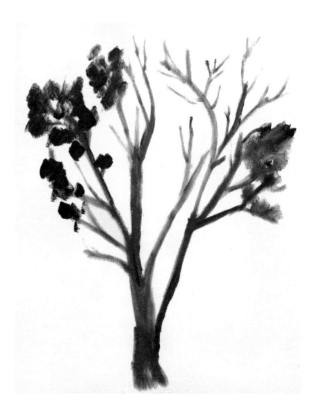

tip

PAINTING A TREE IN PERFECT SYMMETRY CAN CREATE A VISION OF HARMONY AND BALANCE. SOMETIMES TOO MUCH SYMMETRY CAN LOOK MONOTONOUS. BOTH SYMMETRY AND ASYMMETRY ARE CORRECT. SYMMETRICAL PAINTINGS GIVE A SENSE OF BALANCE AND CALM. ASYMMETRY CAN HEIGHTEN INTEREST AND DRAMA.

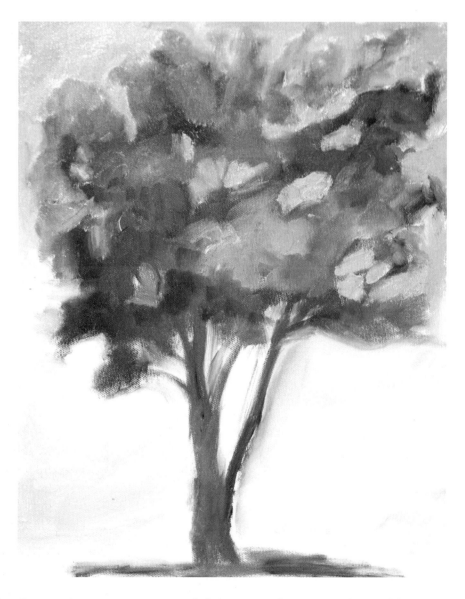

Add white and yellow to the green paint, and dab it in to the outer edges of the tree. Leave "sky holes" between some of the branches and foliage.

PALM TREES

Palm trees are strong verticals. Because of their quirky nature, palm trees can also be a strong diagonal. The branches in a palm tree originate at the center. Bring the fronds out from that center point. You will want to convey wind when you paint a palm tree. The fronds often move in different directions.

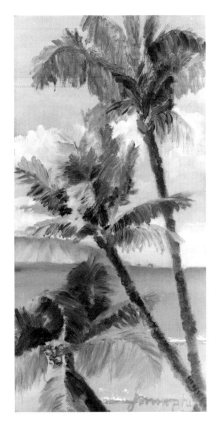

CYPRESS TREES

These tall trees are well-suited for creating vertical strength. They grow upright and usually in a row. Cypress trees grow quite straight in Mediterranean climates. On the California coast, the strong winds blow the trees and often leave them transformed into dramatic diagonal lines.

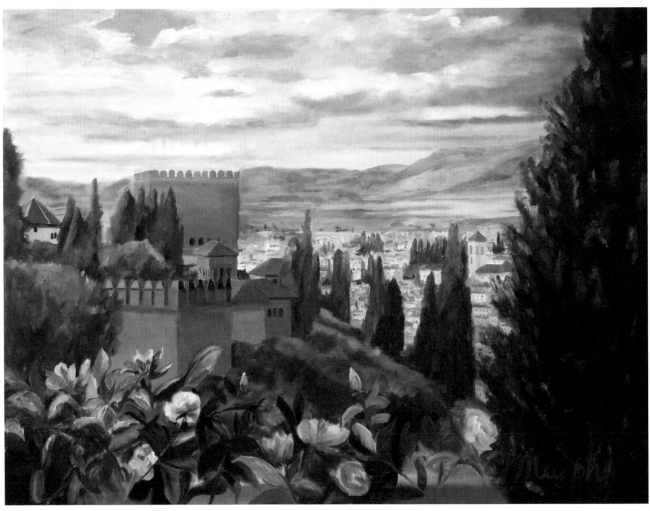

BUILDINGS

A popular subject for artists, buildings carry a strong sense of vertical lines. People relate to paintings with buildings because they create a sense of space, familiarity, and proportion. Keep in mind that buildings are essentially cube forms. (See page 57.)

Windows and doors also bring stability into your painting with their vertical lines. Windowpanes will reflect light differently from one another. Give your windows a sense of life by varying the values of the reflections.

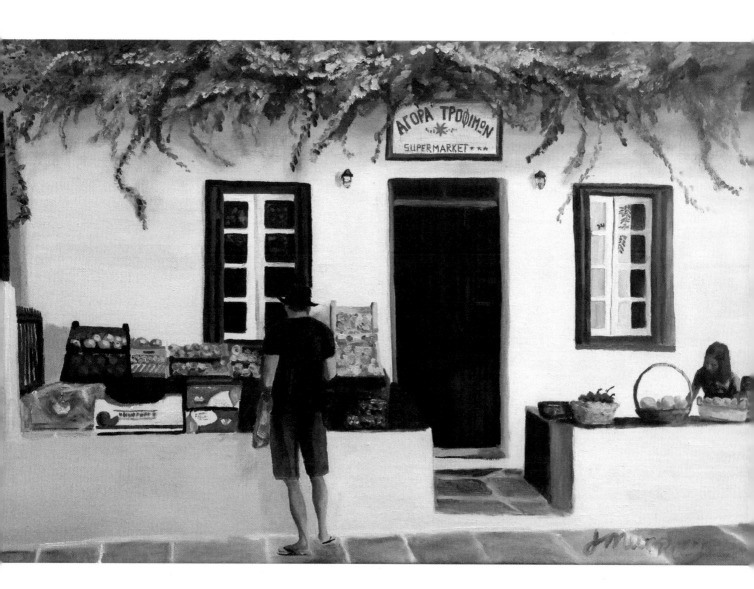

POLES & FENCES

When painting a fence, try making the gaps between the posts unequal. Flagpoles draw interest to them.

SHIPS' MASTS

A simple way of creating masts on ships is to turn your palette knife to the side, and then pull it straight down. Make the height and the distance between the masts uneven.

Water: Reflections & Movement

"AS PRACTICE MAKES PERFECT, I CANNOT BUT MAKE PROGRESS. EACH DRAWING ONE MAKES, EACH STUDY ONE PAINTS, IS A STEP FORWARD."
—Vincent van Gogh, Dutch painter

When observing a lake or another body of water, watch how the reflections appear on sunny versus cloudy days. There are many techniques for creating beautiful reflections in water.

When water is still, it can look like glass. In that state, it is a perfect reflecting surface and acts like a mirror. At other times, the mirror quality might be lost due to wind or waves. No matter how still the water looks, there will always be some movement. Showing this movement will help create a believable painting.

A body of water, such as a lake, is strongly influenced by the hue, value, and intensity of the sky. When the sky changes, the water will change with it. The sun will create different variations in shadow. However, the reflection won't change. The reflection of a straight tree will always go straight down into the water. Use vertical strokes for the reflection of the object in the water; use horizontal strokes to break up the vertical strokes. Horizontal strokes help keep the water from looking too flat.

tip

IF YOUR PAINTING INCLUDES BOTH SKY AND WATER, BLOCK THEM IN AT THE SAME TIME. THIS WILL SAVE YOU FROM MIXING MORE PAINT. THE WATER WILL TYPICALLY BE DARKER THAN THE SKY.

Creating a Reflection

To understand how objects reflect in the water, use this formula to create a building as well as other types of objects.

MATERIALS NEEDED

- ☐ Surface of your choice: paper canvas, canvas panel, or hardboard

- ☐ Flat or filbert brushes

- ☐ Pencil or oil paints in your choice of colors

- ☐ Thinner or water if you're using water-soluble oil paints

- ☐ Rags, paper towels, and/or disinfecting wipes

Using your knowledge of creating and shading forms, draw the shape of a house on a riverbank.

tip

SIMPLE SHAPES WILL HELP YOU UNDERSTAND THIS FORMULA.

Start with the peak of the house, and measure with your thumb and forefinger the distance to the bottom of the house. From the bottom of the house, measure the same distance below it, and mark a dot there. Then use the same formula to find the other points in the house, and place small dots where the water will go.

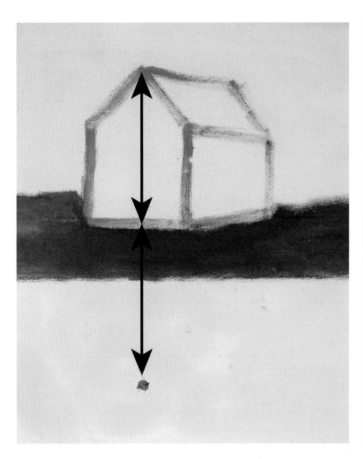
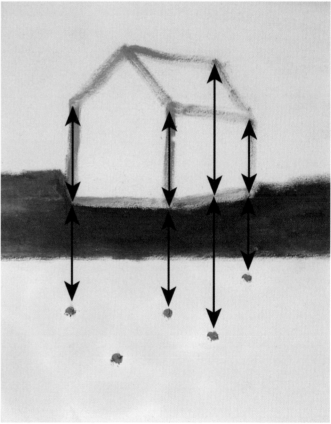

ADDING DETAILS

Wiggle a line between the dots to connect them and form the shape of the house in the water. Use this method to create the door and windows too.

tip

IF AN OBJECT LEANS TO ONE SIDE, ITS REFLECTION WILL LEAN TO THAT SIDE AS WELL.

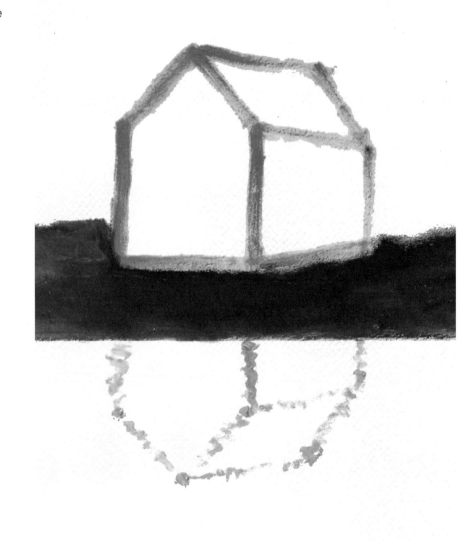

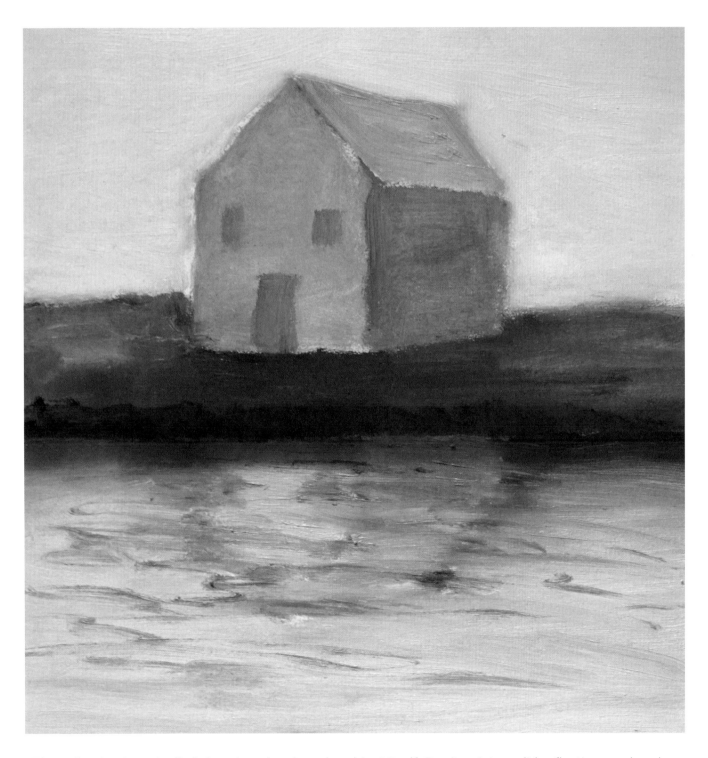

The reflection is typically lighter in value than the object itself. Don't paint a solid reflection, and make sure to paint the suggestion of movement in water.

Painting Water Using Complementary Colors

Once you understand how objects reflect in water, you can use simple methods to create realistic results. This painting uses blue and orange, which are complementary colors, as well as white.

tip

YOU CAN USE CANVAS PAPER, CANVAS PANEL, OR A PRIMED WOOD PANEL FOR YOUR SURFACE HERE. THIS EXAMPLE USES A TAN-TONED HARDWOOD PANEL. THE TAN TONE SHOWS THROUGH AND HELPS GIVES A DIFFERENT ATMOSPHERE THAN A SOLID WHITE PANEL, MAKING THIS PAINTING FEEL ALMOST LIKE A SOMBER DAY.

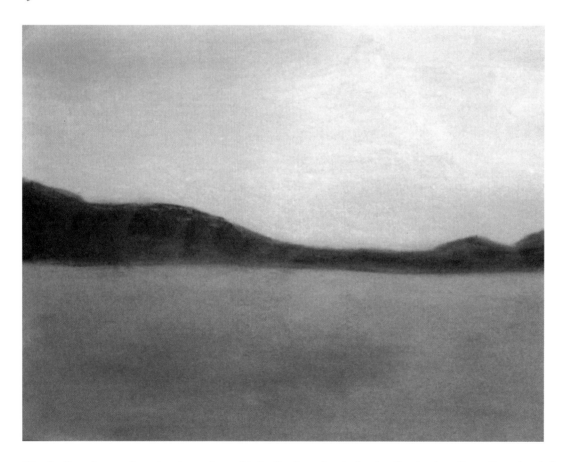

Study the sky and water in nature. Note that water is typically darker than the sky. When considering the direction of your light source, remember that if the light source comes from the right side of your painting, the sky and water in your reflection should also be a little bit lighter on that side.

Trees look most believable when you leave some holes in them so that you can see the sky behind them. You can also dab some of your sky color onto the tree to create a "sky hole."

Block in mountains in the distance. The mountains should be lighter in value and intensity than the areas in the foreground to give the illusion that they are farther away. It's OK if the colors mix a bit.

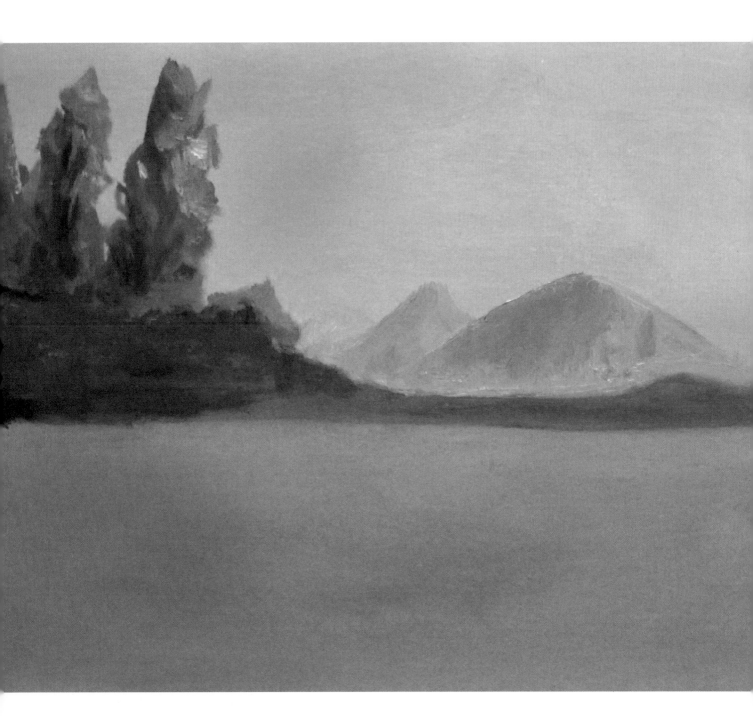

ADDING A REFLECTION

To create a reflection, measure the area above the water with your thumb and forefinger. Measure the same distance into the water, and place a dot. This doesn't have to be precise, so you can also estimate how far into the water the reflection should go. Use the same method for painting the trees' reflections, without adding any details.

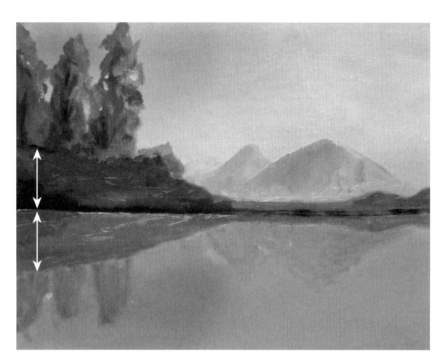

tip

NOTICE THE BUSH TO THE RIGHT OF THE TREES. IT'S NOT TALL ENOUGH TO REFLECT INTO THE WATER, SO YOU DON'T NEED TO PAINT ITS REFLECTION.

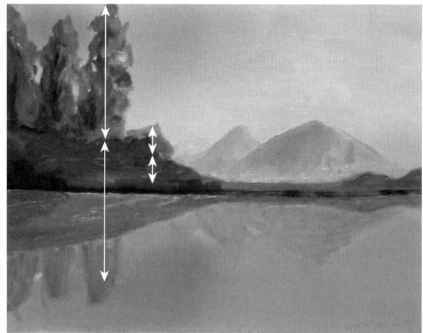

Remember that this is not a photograph, and you want to create suggestions of objects without going into a lot of detail. Create grasses and a small building. Rocks add interest to the water's edge. Make some of the rocks a bit larger than others to create even more interest. Dab the reflections of these objects below the rocks you just painted without being too precise.

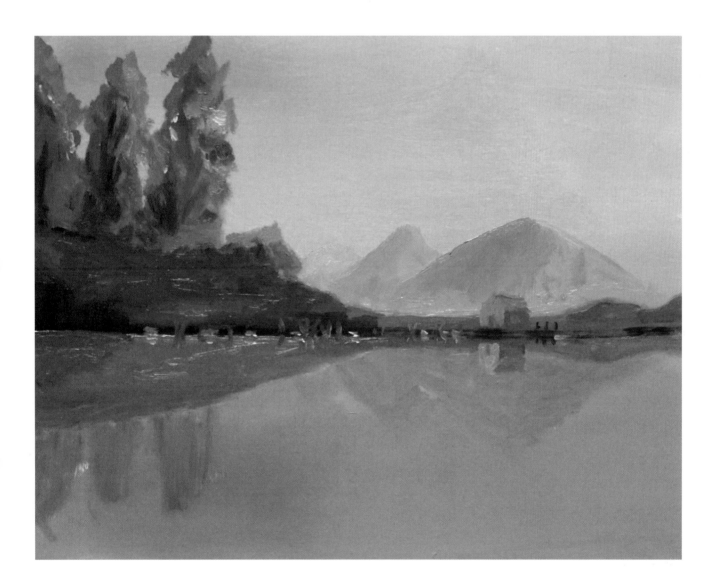

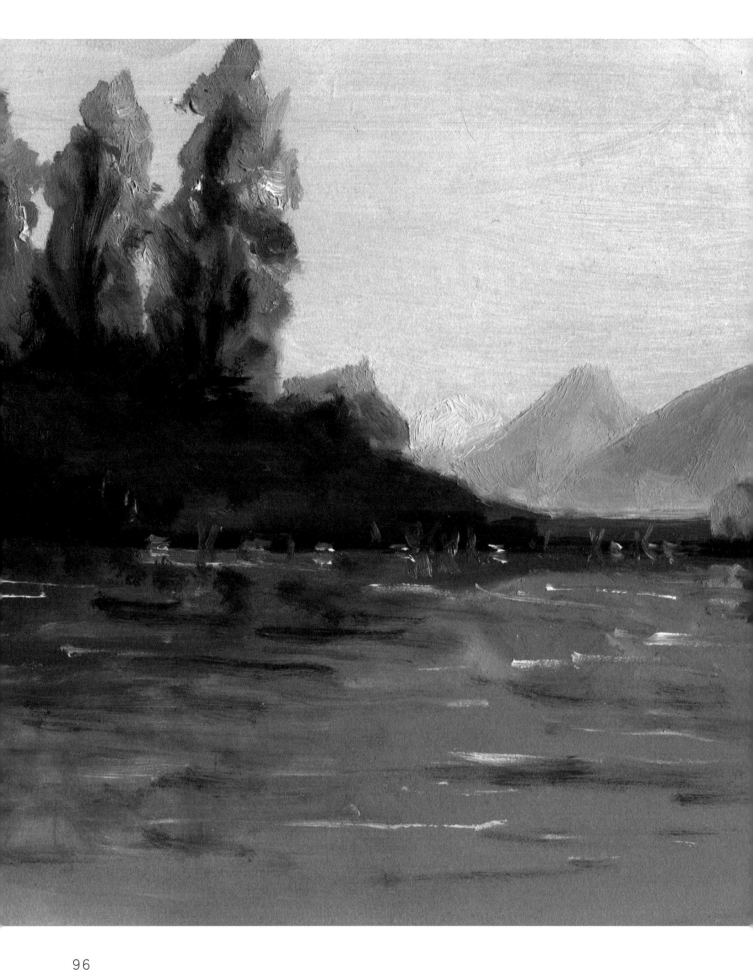

Your painting now shows a perfectly mirrored reflection.

Water is never completely still, so use long and short strokes and a flat brush turned on its side to create movement. Keep wiping the tip of your brush so that it's clean when you drag it across the water. Experiment with adding ripples to the water to create more movement.

TIPS FOR PAINTING REFLECTIONS

1. Painting reflections can be confusing, so use a reference photo for help.

2. Leave out details in the water. It's more important to show the color in the reflected object than the exact object.

3. Pull the paint vertically down into the water for a reflection, and break up this vertical mass with horizontal movement. This helps keep the image from looking flat.

More on Movement

Waterfalls are wonderful subjects to paint. They add an element of excitement because of their drama and movement. If you're lucky enough to get near one, take some time to watch how the water moves. It may look quite blurry. Feel the rush and motion of the water.

Place a flat or fan brush loaded with paint at the top of your surface. Without picking up your brush, pull the paint straight down in a quick motion.

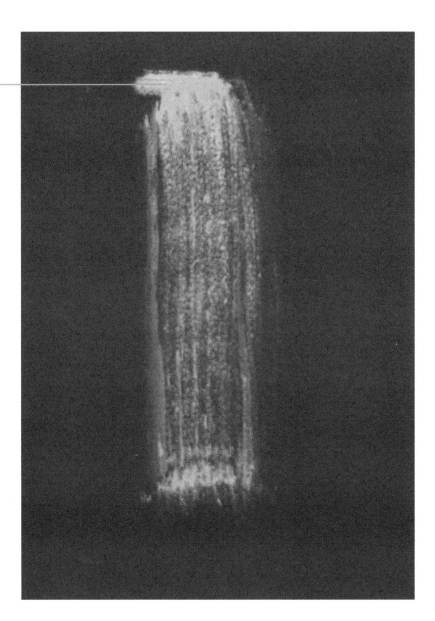

tip

A WATERFALL WILL LOOK MORE REALISTIC IF YOU BLUR ITS EDGES.

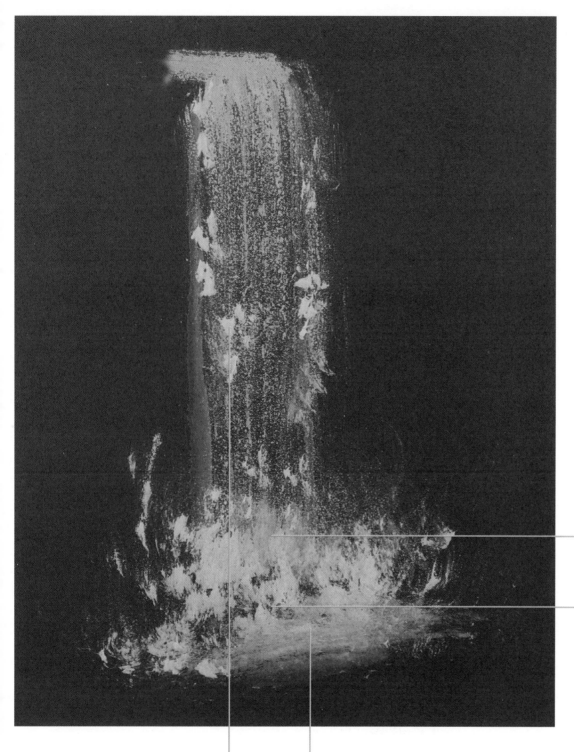

Flick your fan brush up to create spray.

Pull some paint back up into the waterfall.

Use a filbert brush to scumble paint at the bottom of the waterfall.

Flick some paint up along the waterfall to create the impression that water flows over the rocks.

99

Catching a Wave

Learning the simple anatomy of a wave will help you create believable waves.

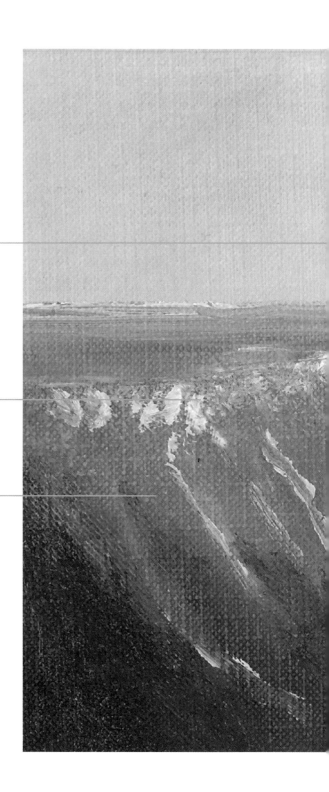

Create a line that comes to a peak, and dip that line to form the basic shape of the wave.

Tap in foam with a fan brush.

Paint a darker value of blue, and then use a dry fan brush and white paint to pull the paint down onto the darker area.

tip

PRACTICE VARYING LINE HEIGHTS AND WIDTHS TO CREATE WAVES OF DIFFERENT SHAPES AND SIZES.

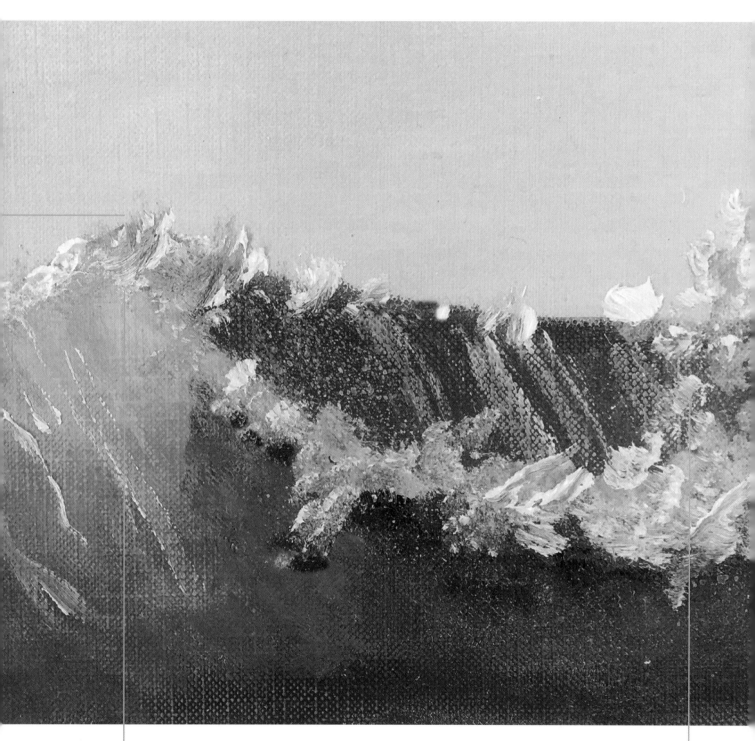

Create the eye of the wave by painting the area underneath its horizontal line a very light tint of green or blue. Lighten this area further, and then blend the two together.

Tap in white paint to create spray.

Painting the Sky

The sky is an integral part of a landscape painting, not just a backdrop or an afterthought. It is important to create harmony between the sky and the land below. To do this, paint small bits of the colors in the landscape into the sky, and paint small bits of the sky into the landscape. Treat them as a unified whole.

The sky is a popular painting subject that can be challenging because the elements are constantly changing—sometimes by the minute. Light changes. Shadows move. Sketching and painting outdoors is the best way to understand the effects of weather and the changing features of the sky.

CLOUDY SKIES

Clouds often make up an important part of a landscape. They add to the mood of your painting and introduce movement. Some clouds appear to be racing across the sky. Higher-stratus clouds invoke calm and serenity.

Spend some time outdoors studying clouds. Watch for combinations of different types of clouds and how they interact. Look for patterns of light and light and dark areas in the clouds. Notice how these values create the forms of the clouds.

TYPES OF CLOUDS

Look at the sky, and you will often see various types of clouds at different levels. If you want an airy feel, paint some cirrus clouds. Cumulonimbus clouds communicate power and drama.

STRATUS CLOUDS are low-lying. They don't have the puffy nature of cumulus clouds. Instead, they tend to be hazy and foglike in nature.

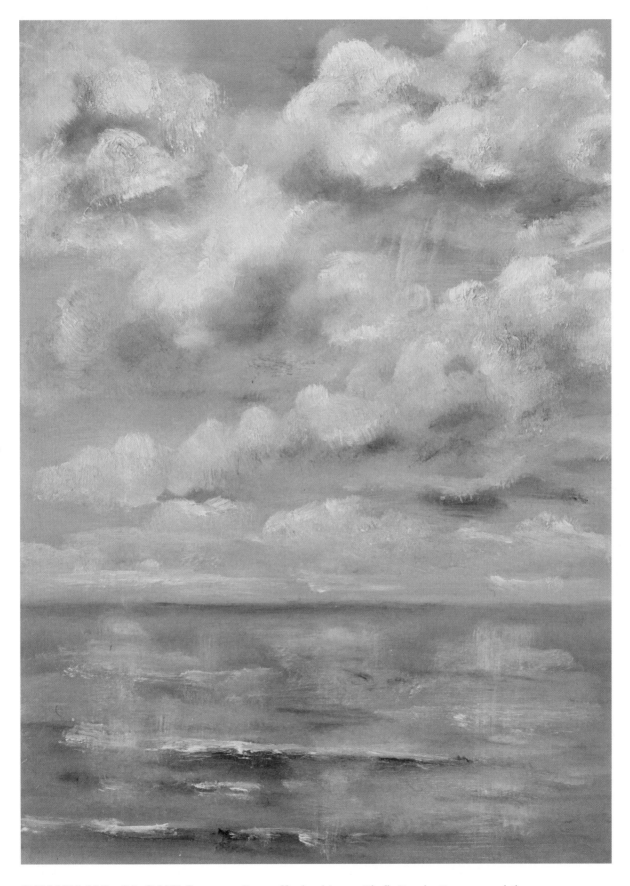

CUMULUS CLOUDS are quite puffy-looking with flatter bottoms, and they are generally lower in altitude.

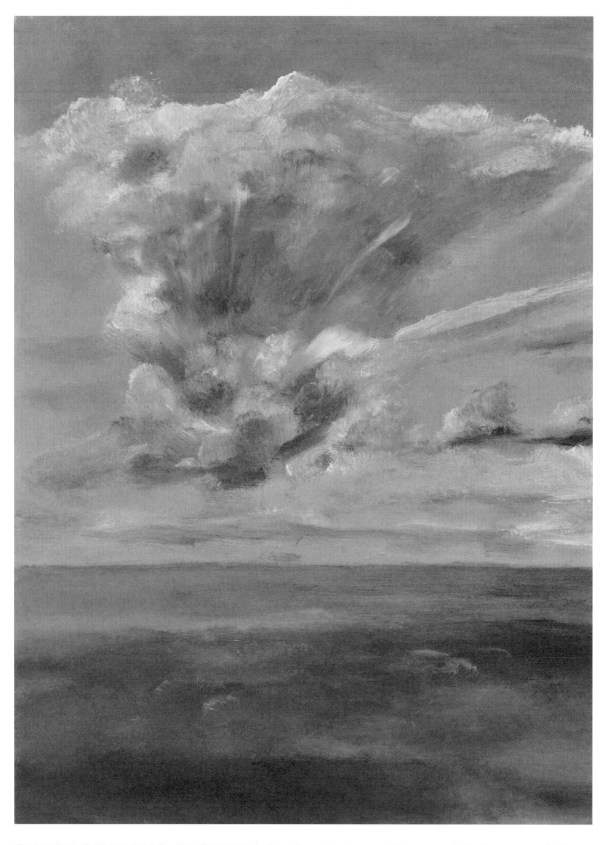

CUMULONIMBUS CLOUDS bring thunderstorms. They are full of water, which makes them appear darker than other types of clouds.

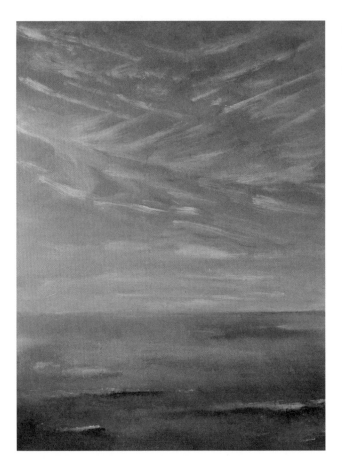

CIRRUS CLOUDS usually form over 18,000 feet. Thin and wispy in nature, they are most often seen during fair weather.

Plan your clouds as you would the rest of your painting. Clouds can add value and importance to the mood and atmosphere of your painting as well as its sense of scale.

Remember that on a cloudy day, there will often be shadows on the objects in the landscape. Look for lights and darks in clouds, and notice how these values create the forms of the clouds. Keep your brushstrokes loose to suggest movement. If you want light, misty clouds, use glazes over the background color. Heavier clouds benefit from thicker paint application.

CLOUD COLOR & HIGHLIGHTS

Clouds contain all kinds of colors. You might look up at the sky and see gray clouds. Instead of using black and white paint to mix a gray, give your clouds personality by mixing complementary colors.

Clouds often take on some of the color of the surrounding areas in your painting. Yellow ochre is a good color for sunlit highlights. The colors don't have to be used at full strength. A mere suggestion of a complementary color in a gray sky will produce a vibrant cloud.

Highlights change depending on the time of day. In the morning and evening, the sun is lower in the sky, and the highlights will be underneath the clouds. At noon, clouds' highlights appear on top. To make your clouds appear richer, try to use color in your highlights instead of pure white.

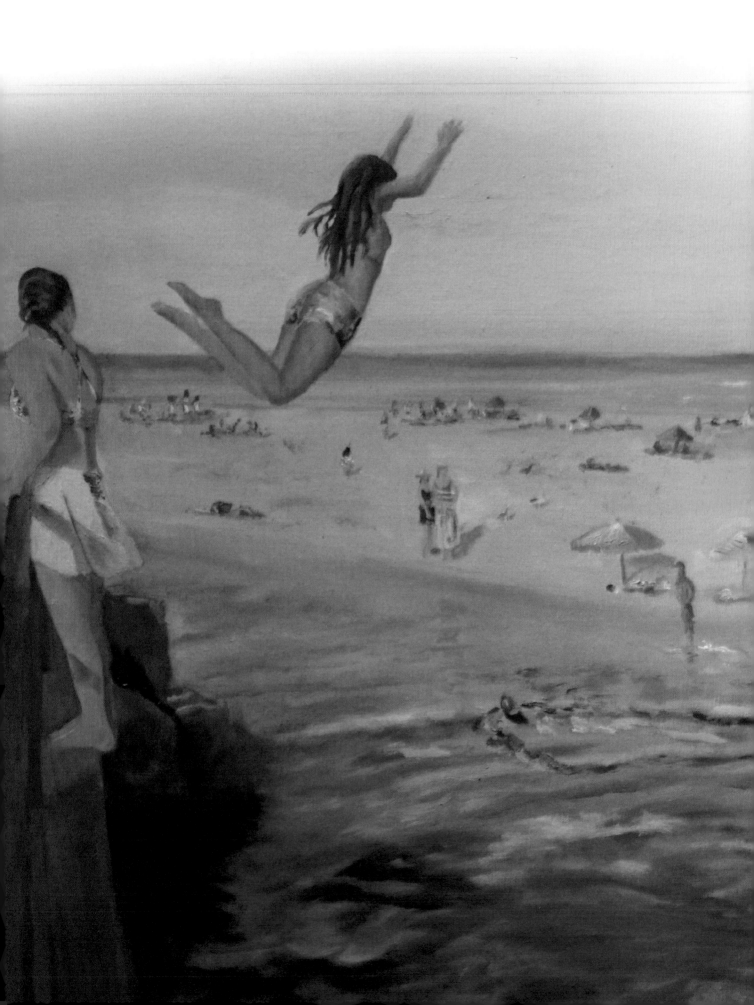

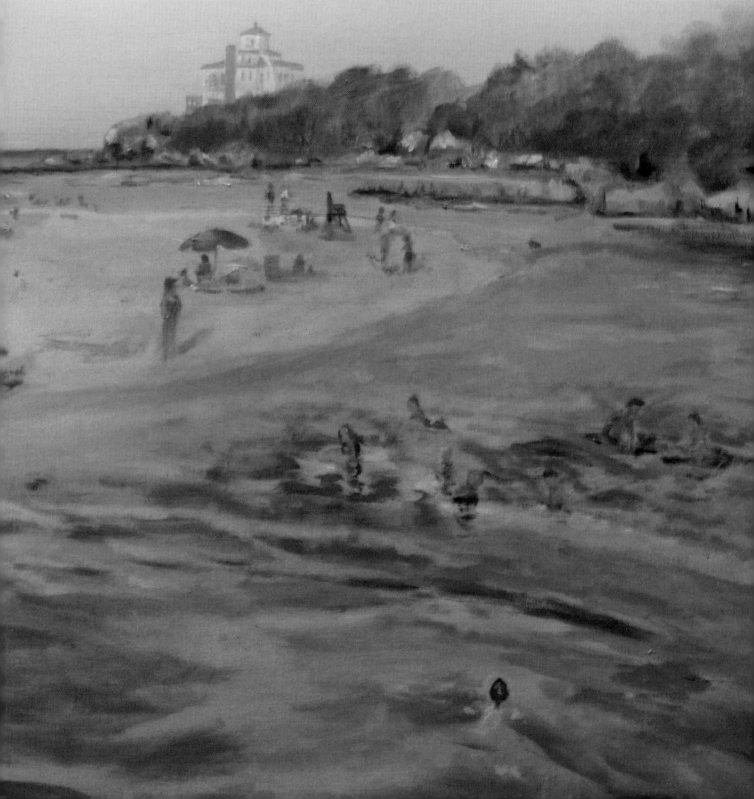

Creating
MOOD & ATMOSPHERE

Showing the Effect of Light

"IN NATURE, LIGHT CREATES THE COLOR. IN THE PICTURE, COLOR CREATES THE LIGHT."

—Hans Hofmann, German-born American painter

Mood and atmosphere show the effect of light in your environment. One of the best ways to achieve this is to paint outdoors. The mood of the painting is often set by the quality of light in the sky.

A ground is the initial flat color that you put on the surface. White is the most inexpensive color to use. However, white can alter the perception of colors you put on top of it by making them seem dull. Because lighter colors are used for highlights in painting, it's best to start with a darker color.

Earth tones are more neutral and can work with any color scheme. They are also less expensive to buy, which is a consideration if you plan to work on a large surface. Another option is to consider complementary colors when choosing a color to lay down first.

tip

START WITH THINNER PAINT. IF YOU START TOO THICK, THE PAINT MIGHT NOT DRY COMPLETELY, WHICH CAN CAUSE CRACKS IN YOUR PAINTING.

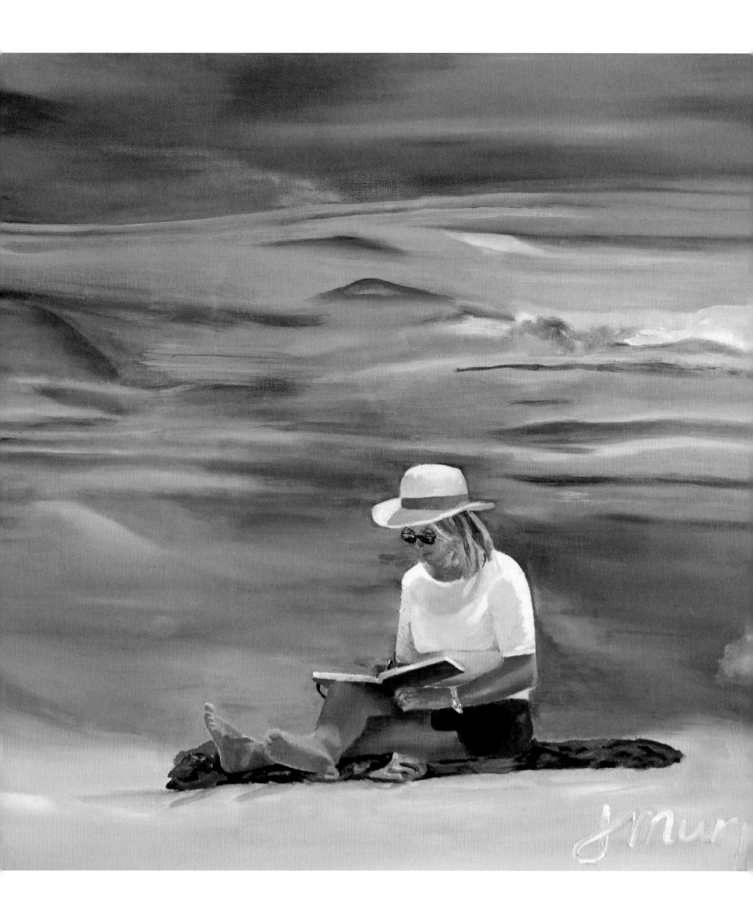

TIPS FOR PAINTING USING MOOD & ATMOSPHERE

As a painter, you are the director of the scene. Planning out your ideas about mood will guide you as you work on a painting. Before you begin, ask yourself:

- What mood do you want to convey in this painting? Think about the reason that you want to paint a particular scene. If you are enthusiastic about the subject, that enthusiasm will show in your final painting.

- What kind of lighting will you show? Will it be a soft, diffused light? Will it have deep shadows and bright highlights? Where is the light source coming from? How intense is the light source? If it's a sunny day, consider pushing the value and color temperature differences between the objects in your painting. On a cloudy day, those differences will be subtle.

- Where are the shadows? How deep or subtle do they look?

- Think about your color scheme. Use warm colors for areas lit by the sun and cool colors for shadowed areas. Yellow brings energy, while a grayed violet lacks energy. Use that grayed violet to your advantage by painting it into the shadows.

- You might be painting outdoors or in your home using sketches or photographs. Which areas of the photo or sketch will you include? Which areas will you exclude?

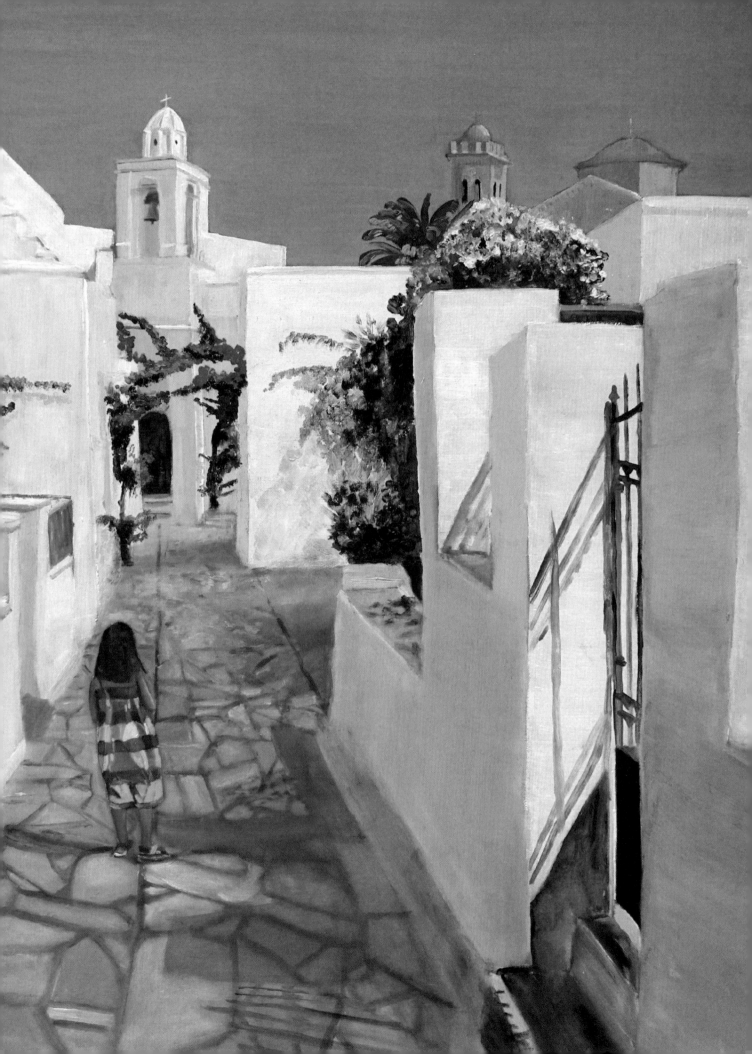

Atmospheric Perspective

"WITHOUT ATMOSPHERE, A PAINTING IS NOTHING."
—Rembrandt van Rijn, Dutch painter

Atmospheric perspective is a method used in painting to show objects receding in the distance. Objects will appear lighter as they move farther away because there is more atmosphere, dust, and pollution between your eye and distant objects. The color of the sky will also influence the objects in the distance. The sky on a clear day appears blue when you look up. But when you look in the distance, mountains will appear blue. On a cloudy day, there is no blue in the sky and objects in the distance will look grayish.

Artists who paint landscapes use the lessons of atmospheric perspective. Using this knowledge will help turn a two-dimensional surface into a three-dimensional world.

tip

USE A SOFT GAZE, AND VIEW YOUR SUBJECT OUT OF FOCUS. YOU'LL BE ABLE TO CONCENTRATE ON THE COLOR AND NOT ON THE DETAILS. TRY TO FOCUS ON THE COLOR ALONE, NOT WHAT KIND OF OBJECT IT IS.

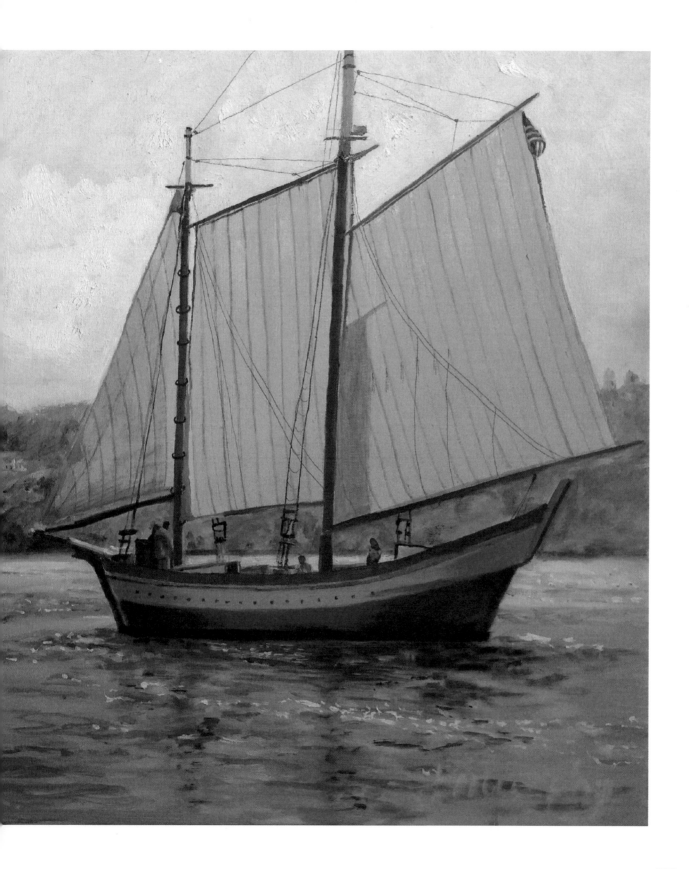

113

Mountains in the Distance

Artists can create atmosphere in a landscape painting by showing objects in the distance lightening in value. One way to do this is to paint several bands of mountains. Choose a blue with a bit of red for the mountains in the foreground. Add some yellow and white to the blue in the next set of mountains, and more yellow and white for the third set.

MATERIALS NEEDED

- ☐ A canvas to which you have applied a ground

- ☐ Bristle brushes, filbert and flat brushes, and a sable round brush for any details

- ☐ Oil paint colors in red, blue, yellow, gold ochre, violet, and white

- ☐ Thinner or water if using water-soluble oil paint

- ☐ Rags, paper towels

tips

IF YOU'D PREFER TO CREATE AN IMAGE OF YOUR OWN SHOWING ATMOSPHERIC PERSPECTIVE, SKETCH IT OUT FIRST. MOVE THINGS AROUND, AND PLAY WITH IDEAS. PAINTERS AREN'T PHOTOGRAPHERS AND DON'T NEED TO INCLUDE EVERYTHING. JUST BECAUSE SOMETHING IS IN YOUR VIEW DOESN'T MEAN THAT YOU HAVE TO INCLUDE IT.

Sketch a line between the trees and the ground, and another for the tops of the trees and mountains receding into the distance. Scrub in the row of trees, mixing in some red to change their value. Create the mountains using violet mixed with yellow and white. Let the mountains and the trees blend.

Add white to the mixture, and paint the next set of mountains. Repeat for the most distant mountains. Make the yellow more intense on the left side. Bring some of the yellow into the violet mountains. Add some yellow to the foreground.

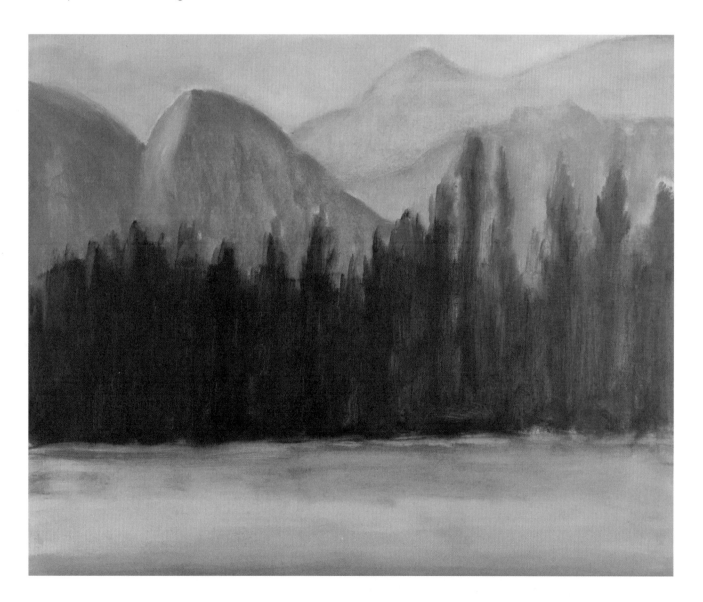

Mood + Warm & Cool Temperatures

Cool colors, such as blue and green, suggest calm and peace. Warm colors, like red, yellow, and orange, suggest vitality and energy. Take advantage of cool and warm temperatures to create mood in your paintings.

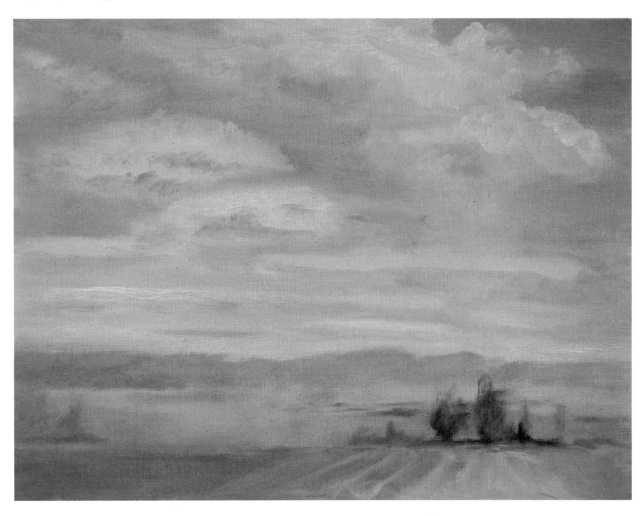

SUN

When painting the sky on a sunny day, you might be tempted to paint with the brightest blue on your palette. Keep in mind that the sky will look lighter in value than the water or land below it. Use an orange or rosy ground. You can also use subtle flecks of orange, yellow, and/or red to paint the sky. Adding warm colors will help create the warmth you feel on a sunny day.

Shadows appear deeper on a sunny day, and midday sun can cause extreme value changes between sunlit areas and shadows. The color of the shadows is influenced by the local color (the color of the object itself). When creating shadows, build them up using glazes (page 53). The colors will bounce through the layers, giving a luminous feeling. Morning and evening light is generally softer than mid-day sun.

FOG & MIST

A foggy day can create a mysterious atmosphere. Shapes are softened and blurred in the fog and mist, and contrasts between light and dark areas are minimal. There won't be high contrasts between light and dark areas. If you plan to paint your foggy day in blue tones, consider working on a ground of earth tones.

STORMINESS

Storms create an atmosphere of drama and uncertainty. Think about your brushstrokes. Use broad, quick strokes to imitate the movement of the clouds.

NIGHTTIME

At night, everything looks black at first. Let your eyes adjust to the scene. What is the darkest dark that you see? What is the lightest light? Keep your objects soft with less detail.

GLOWING LIGHT

Create light that is lighter than the areas around it, and it will seem to glow. Adding yellow-orange near yellow can reinforce the glow. Try not to dull the yellow by mixing certain colors into it. Use violet and other cool colors near the area that you want to glow.

INTERIOR LIGHT

The light is always changing in interior spaces. Who frequents this place or who lives there? Is there a sense of peace or vitality? How does the lighting set the mood?

tips

CHOOSE A PLACE WHERE YOU CAN CREATE A PAINTING AT DIFFERENT TIMES OF THE DAY. THIS COULD BE A NEARBY OPEN SPACE OR PARK OR THE SCENE FROM YOUR WINDOW. FIND DIFFERENT WAYS TO PAINT THE SCENE. WHAT HAPPENS TO THIS SCENE ON A CLOUDY DAY VERSUS A DAY FILLED WITH LIGHT AND SHADOW?

Still-Life
PAINTING

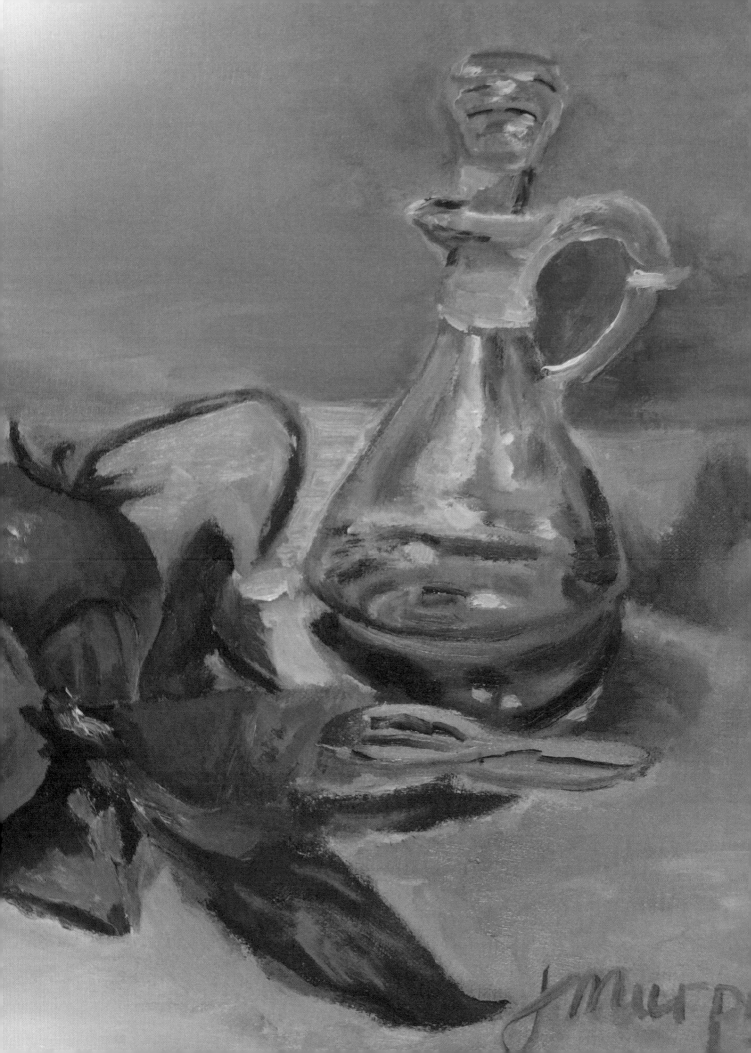

Introduction to Still Lifes

Still-life paintings are arrangements of mostly inanimate objects. These objects can be natural—such as food, flowers, plants, rocks, and shells—or they can be everyday objects found around your house. Books, vases, plates, fabric, jewelry, and candles are just some of the objects that you might want to use for a still-life painting.

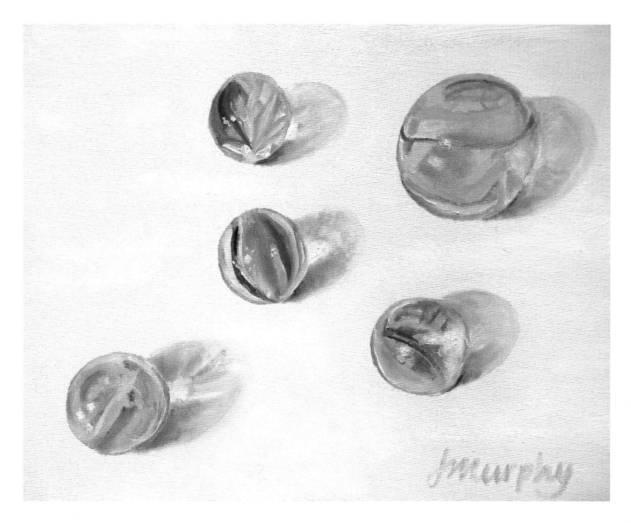

IDEAS FOR STILL-LIFE PAINTINGS

Still-life paintings can be arranged in a variety of ways. The objects can be personal, cultural, religious, or whimsical. You can even bring your own personality into a still-life painting by choosing objects that represent your favorite hobbies.

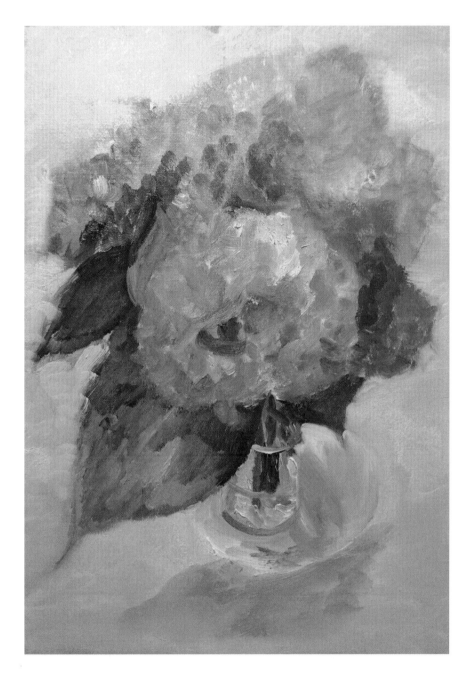

LIGHTING

Set up consistent lighting using a lamp placed near your still-life composition. If you are right-handed, place the lamp on the left side of your still life, and vice versa. This way, your hand won't cast a shadow from the lamp onto your painting surface.

tip

START A COLLECTION OF INTERESTING OBJECTS THAT YOU MIGHT WANT TO INCLUDE IN STILL-LIFE COMPOSITIONS. VISIT GARAGE SALES AND THRIFT STORES TO FIND CHEAP, FUN OBJECTS.

Painting with a Singular Focus

MATERIALS NEEDED

☐ Oil paints in white, green, yellow, and yellow ochre

☐ Your favorite painting surface

☐ Flat and filbert brushes

☐ Thinner

☐ Pencil

☐ Rags, paper towels

Choose a favorite book, and begin by drawing the outline of the book in pencil or thinned oil paint.

Then load your brush with paint, and lay in the flat color of the front and spine of the book. After adding the depression area between the spine and the front cover, paint the pages. The background and shadow should show how the light hits the book. Use red in the shadow as you lay in the flat color of the book cover and the spine.

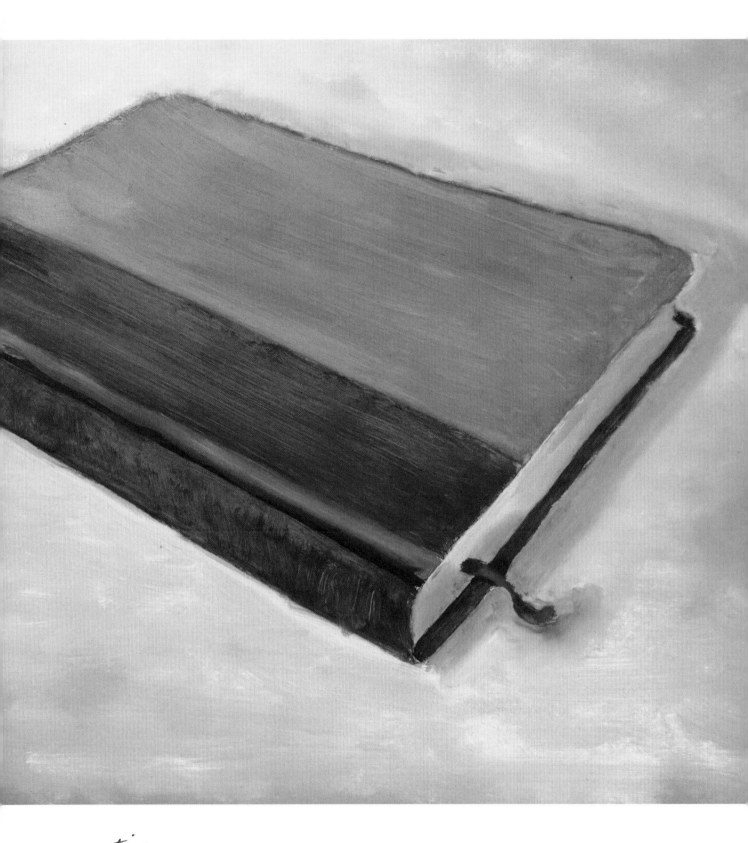

tip

TO CREATE DETAILS, ADD A TITLE TO THE SPINE OR OTHER DECORATIVE MARKS.

A Study in Composition

Still-life painting is a great way to study composition. Remember to break down an object into its basic forms: sphere, cube, cylinder, cone, or a combination of these. This will make it easier to begin painting.

MATERIALS NEEDED

- ☐ Oil paints in white, green, yellow, yellow ochre, violet, and orange

- ☐ Use a canvas for this project. You might be so proud of your results that you have the painting framed!

- ☐ Flat and filbert brushes

- ☐ Thinner

- ☐ Pencil

- ☐ Rags and paper towels

Paint a canvas with a thinned red-violet. Use a rag to wipe the color into a rosy pink. Then use a pencil or thinned-out yellow ochre paint to sketch in three pears. Their shapes can vary.

Use a bristle brush to scrub in the pears in yellow-green or yellow ochre. Determine your light source, and then paint the shadows on the yellow-green pears. Yellow-green's complement is red-violet; use this to create a rich shadow. Yellow's complement is violet; use this for the shadows on the pear in the center. Add a splash of orange on the right side of the pears.

Massage some white paint into the three pears to create highlights. Ground the pears by creating shadows under them, and create a table for your pears to rest on.

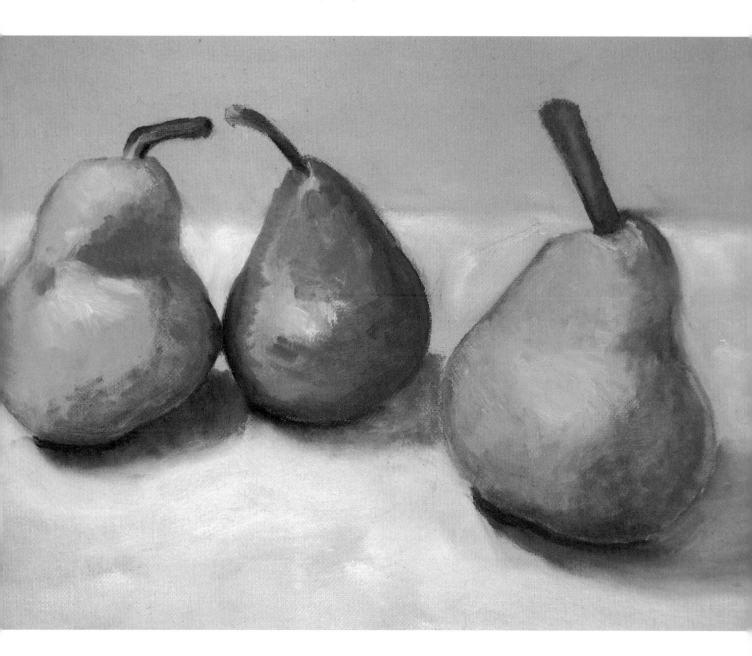

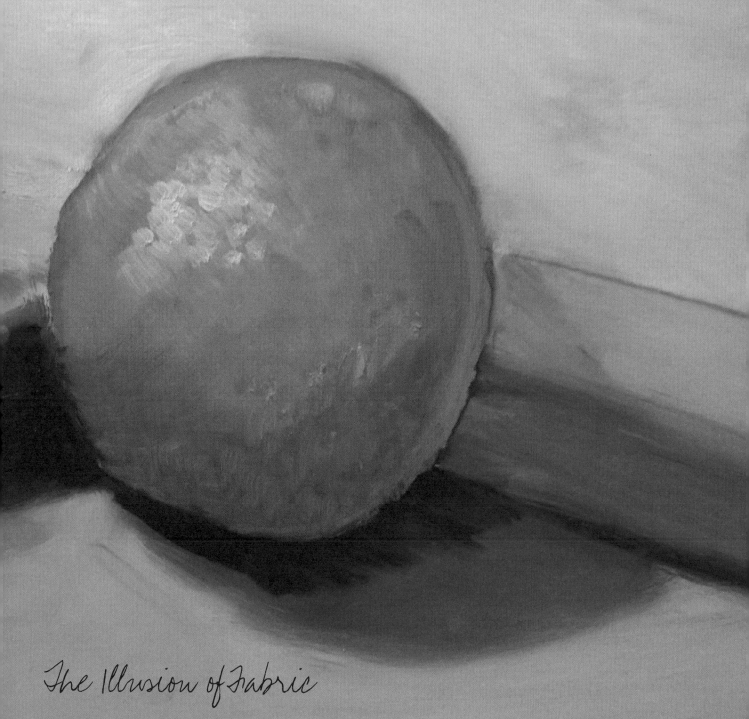

The Illusion of Fabric

Fabric can hold a still life together. It forms the base for objects to rest on, and it can be draped behind objects to show gentle folds.

When painting folds in fabric, choose a solid fabric without patterns or details. Start with just a few folds, and practice painting those. Use a pencil and sketchbook to draw and shade the fabric.

Folds can be manipulated to create lines that will draw the viewer into an area. Remember that you are the director of your painting and you get to decide where you want the viewer to look.

Use diagonal folds to show lines with energy. Place a horizontal fold behind the object to stop the viewer's eye from leaving the canvas.

About the Artist

Jan Murphy was born in Palo Alto, California, the heart of the innovative Silicon Valley. She now lives in nearby Menlo Park with her photographer husband, Ed, whose photographs are great reference material for her. Raised by an award-winning architect dad and an interior-designer mom, Jan spent a childhood awash with creativity and inspiration. She is one of the lucky ones who has always known that her path would be in art and credits her parents with creating an environment that fostered exploration in the arts.

Jan received her B.A. in design from the University of California, Los Angeles. She has worked as a successful graphic designer and an art director for corporate and nonprofit companies. Her background in design shines through in her painting style.

Inspired by the Impressionists, you might find Jan painting *en plein air* in Europe, Hawaii, Massachusetts, or the San Francisco Peninsula. She exhibits her art throughout California and has collectors in the United States and Canada. She is a member of the Oil Painters of America.

Jan is interested in light and the interaction of color. She often starts each painting with a rose-toned canvas. Her goal is to awe the viewer with the colors and designs on her canvases.

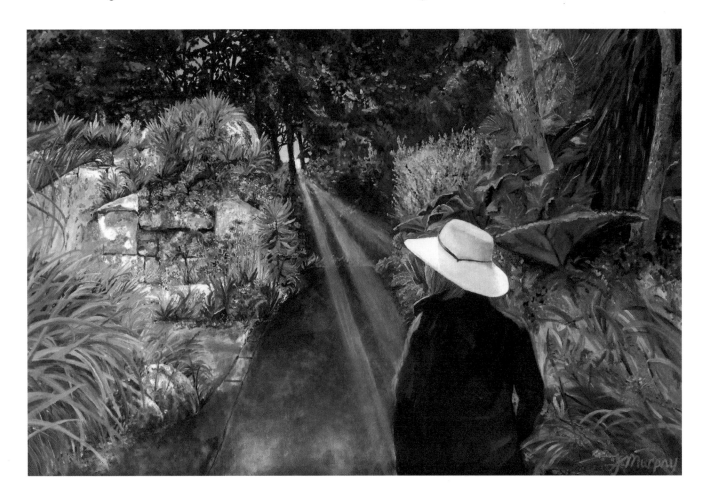